Painting the Tales

THE FOLK TALES COLLECTION

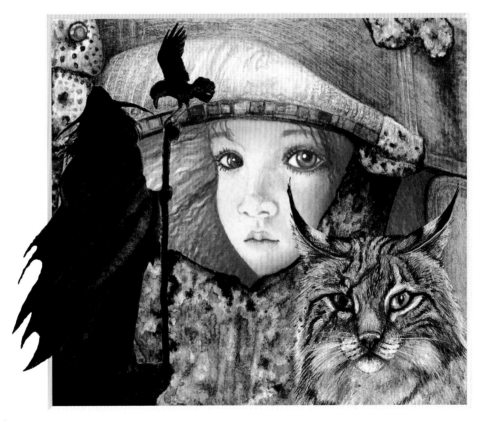

KATHERINE SOUTAR

FOREWORD FROM TAFFY THOMAS, MBE

The
History
Press

First published 2018

The History Press
The Mill, Brimscombe Port
Stroud, Gloucestershire, GL5 2QG
www.thehistorypress.co.uk

British Library Cataloguing in Publication Data.
A catalogue record for this book is available from the British Library.

ISBN 978 0 7509 8601 4

Typesetting and origination by The History Press
Printed in Turkey

Contents

For Annette

K Southwo

x

Acknowledgements

I owe a huge debt of gratitude to my family and friends for their support, encouragement and good humour over the years. I would particularly like to thank Bill, Tam, Mary and Holly for being such patient and cooperative models. I would also like to thank the many people who follow and encourage my adventures in illustration on social media.

Thanks are also due to the many wonderful storytellers whose books I have been lucky enough to work on; without your skills and your stories there could be no pictures. It has been an enormous pleasure to get to know so many of you, even though I have yet to meet a number of you in person. My special thanks go to Taffy Thomas for writing the foreword to this book for me.

And lastly, my thanks to The History Press for such a long and mutually fruitful relationship. Working on this series has been an inspiring, satisfying and occasionally challenging experience I would not have missed for the world.

I would like to dedicate this book to my parents, Joy and Keith– who always encouraged me to feed my imagination, follow whatever path in life I felt most passionate about and be true to myself. That I didn't even realise this fully until much later makes me even more grateful.

Foreword

It is an honour to be invited to write the foreword for this book about the work of a talented and prolific artist who has for years produced beautiful colour illustrations and book covers. Here is her selection of eighty-four magical cover illustrations from The History Press' Folk Tales series. I am delighted that this includes her covers of a couple of my books from this series.

Katherine has spent so long immersed in the imagery and iconography of folklore, ballad, story and customs that the art she makes is jewelled with traditional folk culture references. This is just as well, for when we read or listen to a story we build up our own picture of the protagonists and locations involved. If an artist's film or illustration doesn't match the picture in our head then we are instinctively disappointed. When you visit our stories, as we folk tale authors hope you will, should the images not fit the ones in your head then go with your own, but I am prepared to bet that your ideas will not be too dissimilar to Katherine's. For she listens well to the tales and re-reads the text to make it into, for her, a truly visual art.

Shortly after I was appointed First Laureate for Storytelling in 2010, an officer at the Arts Council of England asked me for advice. They were unsure how to categorise the art of oral storytelling. Should it be pigeonholed with poetry, playwriting and prose as a literary art, or with drama and theatre as a performance art? I surprised them when I told them that, in my opinion, it is a visual art. Admittedly mostly the pictures are virtual, as the listener feeds on the riches of the storyteller's language and imagination to build pictures in their own mind.

This collection from Katherine Soutar vividly brings this idea of the link between story and visual art to fruition. So I commend her work to you. It is a joy.

Taffy Thomas, MBE
The Storyteller's House,
Ambleside,
The Lake District

Introduction

I have always been drawing. It was a compulsion when I was a child, I filled the interiors of my father's books with fantastical animals until my exasperated parents managed to impress upon me that only 'blank' paper was for drawing on. My art degree though was actually in 3D, glass with ceramics (I was utterly seduced by glass when I went to visit the college and have recently started working with it again).

Drawing became a major drive in my life once more when I became artist in residence in a psychiatric hospital and went on to train as an art psychotherapist. Helping people to find ways to express themselves and their personal stories visually also meant I found myself drawing, painting and writing endlessly in the evenings after I got home as a way of exploring my own feelings too. I often wove poetry and prose into the work I made.

My involvement with illustrating for storytellers began after I joined the team at Festival at the Edge, the long-running and excellent storytelling festival in Shropshire. I started to be approached by storytellers who had seen my work with requests to do some for them. The first book I illustrated was *Seeds on the Wind* by Tim Bowley. Then in 2008, when The History Press had just started commissioning writers for their Folk Tales series, Mike O'Connor showed them some work I had done for him and the result of that fortuitous conversation now rests in your hands.

Writing here about eighty-four of the covers I have done over the past nine years for The History Press has been an interesting experience and, occasionally, a frustrating one. Going back and looking at much earlier work is often a tricky thing for an artist to do and I am aware that I would have approached some of the first ones I did differently had I been working on them now. It was also often a little difficult to cast my mind back several years and tap into what I was thinking at the time as I make few written notes, and retain even fewer. I have, I hope, matured as an artist and illustrator during this time and my engagement with more recent works is fresher and often quite passionate. I have also become more aware of recurring themes and archetypes in stories, of how to find the elements that need to be pulled out in an illustration to help people discover the story for themselves. The illustrations I feel have been most successful leave that space for the viewer; that space in which the story also finds you.

There have been a few occasions when on my first read through of a text something has jumped out at me immediately and with such force that I knew it would be the cover, even though I had yet to read the rest. *Ceredigion Folk Tales* was one of these, as were *Armagh Folk Tales*, *Fife Folk Tales* and *Galway Folk Tales*.

Of course, that is part of the magic of storytelling; whether spoken or written, it can sometimes conjure an image so strong, so complete, that I can't wait to commit it to paper, even though making it work and look the way it did in my head can be a long and frustrating process on occasion. One experience of this was the cover for *Derry Folk Tales*, which went through several incarnations before what came from my hand worked for me as well as what floated about in my head.

I am a pretty old-fashioned illustrator and all of my work is done on watercolour paper with pencils, watercolours and inks. Sometimes I may do a little post-scanning enhancement in Photoshop but what you see on the cover is pretty much exactly what I have committed to paper at my little desk under the window.

People often ask me, 'Which folk tales have stayed with you? Do you have favourites?'

This is such a difficult question as there are so many. I found myself crying on reading the story I used as the cover for *Cumbria Folk Tales* by Taffy Thomas, and again when I heard him tell it at my exhibition in Scotland the following year. *Kilkenny Folk Tales* contains an unusual variation on the werewolf story that I found fascinating. The cover for *Northumberland Folk Tales* features my son Tam as Tam Lin, and I have a real affection for both the image and the ballad. *South Yorkshire Folk Tales* features an emotional and visceral tale of a battle between man and beast that leaves you with a breathless respect for both. The Sutton Hoo helmet which features on the cover of *Suffolk Folk Tales* is something I return to gaze at often at the British Museum. I could go on, but I think the ones that abide have touched something in me in some way. And changed me just a little.

Every tale, every book, leaves me with something that enriches me and feeds into what I do next. I have been incredibly grateful for the chance to work with so many unique voices, so many tales told with a deep understanding of their history, legacy and local value combined with the flair of an exponent of the oral tradition that makes this series so special.

My work can both represent stories and give birth to new ones in the viewer; it makes me very happy to be part of an ongoing tradition of the stories we tell ourselves and each other to make sense of our shared experience and the world we inhabit.

Katherine Soutar, 2018
www.katherinesoutarillustration.com

Cornish Folk Tales

BY MIKE O'CONNOR

The cover for *Cornish Folk Tales* has a special place in my heart and is appropriate for the first in this book as before it became a book cover it was a CD cover design I produced for Mike O'Connor. He showed it to The History Press one day and recommended me as an artist to work with. The rest really is history and I am forever grateful to Mike and for the subsequent long association I have had with The History Press.

The cover depicts the flight of Trevillian from the inundation of Lyonesse and it was one of my earliest illustrations for a specific story. I think at this point I was still learning that allusion and suggestion can be as effective as a straightforward representation in illustration, and it would be interesting to see how I would approach it if the text were handed to me now.

One day, and some say it was in 1099, there came the greatest storm that ever there was. The great waves broke down the sea defences and the water came rushing in across the fields. All of Lyonesse was submerged and only one man escaped. His name was Trevillian; he came from Basil, near Launceston. Some people say he was one of King Arthur's knights. When Trevillian saw the waves approaching he leapt on his milk-white steed. There was no time to put on a saddle and bareback he galloped ahead of the waves. But the racing tide was faster than even the swiftest horse. Soon the water was lapping at the horse's heels. Then the horse was splashing through shallow water. For a perilous moment the horse stumbled as the great waves swept it off its feet. Trevillian held on tight with his hands and his heels. After what seemed like minutes, but can only have been seconds, the horse found itself swimming towards the shore. Patiently it swam, then its feet touched bottom and it was able to walk to safety. So it was that Trevillian was the only man to escape the drowning of Lyonesse. His successors, the Trevelyans, live on to this day.

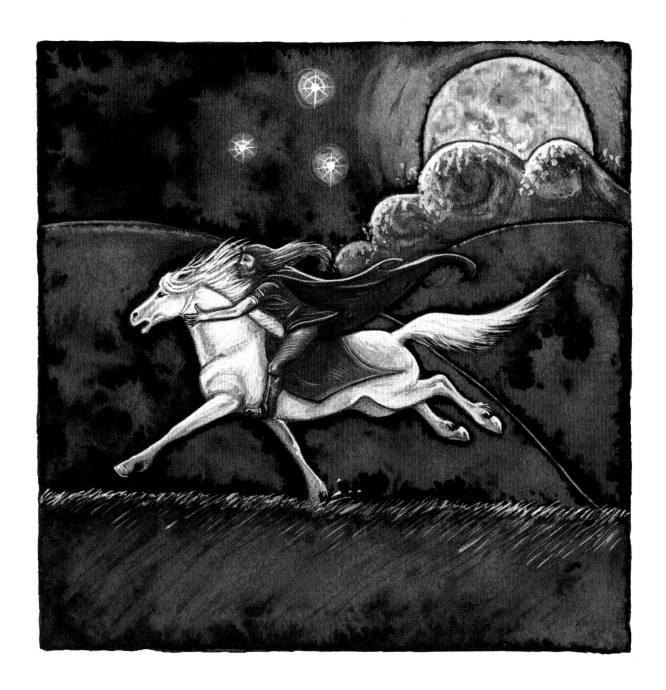

Worcestershire Folk Tales

BY DAVID PHELPS

'Who put Bella in the Wych Elm?' This story is probably the most contemporary tale I have illustrated as well as one of the few that is a real-life mystery, and still not really solved at that.

I was at art college in Stourbridge in the 1980s when I first encountered this story: a local monument had the above question scrawled across it in large black letters, and although curious about it I was busy with being politically active, exploring my independence and making art, as most of us were back then.

I don't remember when I discovered the tale behind that cryptic graffiti but was certainly aware of it by the time I received the text for *Worcestershire Folk Tales*, and when I read the full story I was fascinated by the details of the story and its resistance to being either completely forgotten or completely solved.

A woman's body was found hidden in the interior of a wych elm, possibly the only elm genuinely native to Britain. This particular one was heavily pollarded, giving it a strange appearance with densely packed thin branches above a thick and hollow trunk. I found a photograph online of this tree and wanted very much to use it. The problem of portraying the story without straying into gruesome territory then presented itself. I decided to depict Bella as an absence, a space within the tree; we still can't be sure who she was exactly or what her story ultimately will be, so this seemed fitting. She also has power in her anonymity and here she is a part of the tree, and the landscape, forever.

Elms used to be associated with melancholy and death, perhaps because the trees can drop dead branches without warning. Elm wood was also the preferred choice for coffins. In Lichfield it was the custom to carry elm twigs in a procession around Cathedral Close on Ascension Day, then to throw them into the font.

David Phelps, author of *Worcestershire Folk Tales*, said the following:

I have to admit that, when I first saw the illustration, I looked at it for a long time. Wow, this is dark! But my partner, the storyteller Valerie Dean, loved it and I trust her aesthetic judgement more than I trust my own. Of course, it had to be dark, it was about an unsolved murder. The more I have looked at it the more I see Valerie was right. It transforms poor murdered Bella from victim to powerful nature spirit and is a beautiful resolution to a sad story.

Hampshire and Isle of Wight Folk Tales

BY MICHAEL O'LEARY

I am rather attracted to odd creatures and Michael O'Leary's humorous retelling of the Wherwell Cockatrice story appealed to me on a number of levels. It was the first cockatrice I had come across in the series and it allowed me to utilise some sketches I had made of a breed of chicken called the Transylvanian Naked Neck that I nearly acquired myself a few years ago. 'They are incredibly good layers,' the breeder pronounced hopefully as I dubiously regarded possibly the strangest hen I had ever seen. The cockerel was magnificently weird and not a little nightmarish, and although for egg-laying purposes I eventually opted for a hen with a beard and a Beatle haircut, the naked necks continued to fascinate me. The cockerel made the perfect head model for the cockatrice and I decided to keep the splendid legs too, which always remind me of dinosaurs or dragons.

Creatures like the cockatrice fit into a long tradition of composite monsters which haunt our dreams and stories, as well as medieval bestiaries and heraldry. He is usually said to be born from an egg laid by a cockerel and brooded by a toad, or occasionally a snake. A deadly stare was his power and curse, and only weasels were said to be immune to it. A cockatrice could be killed by making it look into a mirror (as Michael does) and could also be killed by the sound of a cock crowing, which apparently led folk in infested areas to carry one about with them, which as someone who has actually handled an angry cockerel I can only imagine was a little inconvenient!

The Elizabethans utilised the cockatrice extensively in poetry and literature and I leave you with this quote from Shakespeare's *Richard III*, where the Duchess of York compares her son Richard to a cockatrice:

> O ill-dispersing wind of misery!
> O my accursed womb, the bed of death!
> A cockatrice hast thou hatch'd to the world,
> Whose unavoided eye is murderous.

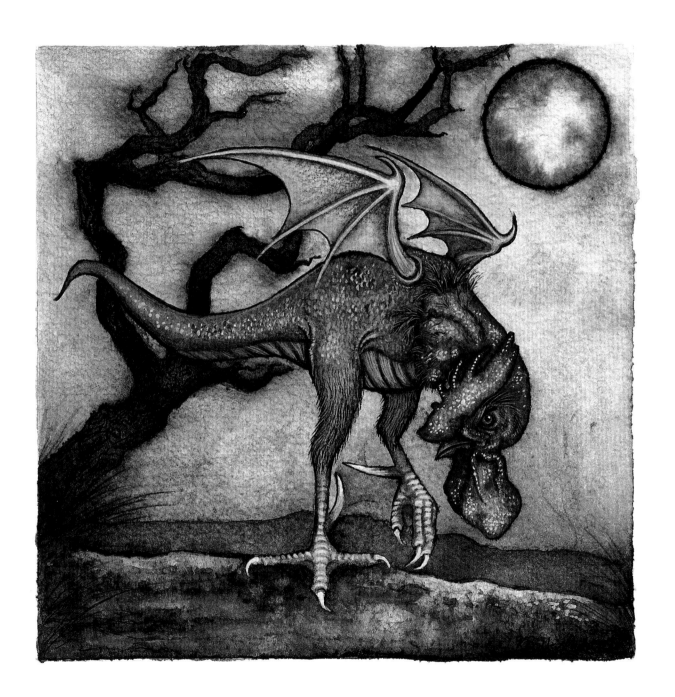

London Folk Tales

BY HELEN EAST

I lived in London for five years and my dad lived there for the last thirty-five years of his life and had a keen interest in its history and folklore, so I was very pleased to find that *London Folk Tales* contained many fascinating tales unique to London and so much information about the history of this great city.

The cover is inspired by 'The Tosher's Tale'. Being a Tosher was an occupation peculiar to London's incredible network of drains and sewers; they hunted down there for coins and valuables lost down the drain or washed up from the foreshore. If you knew where to look there was a reasonable living to be made. But it was a hard and dirty life, the working conditions were difficult and you could get caught out by rising waters and drown, or become trapped down there and die a lonely death surrounded by rats.

Yes, the rats – the Toshers shared the sewers with thousands of them and folklore and stories about them were the subject of many a whispered conversation amongst their company late at night. The most compelling of these were stories of how the Queen of the Rats would favour a human man if she took a shine to him. Contriving to meet him by chance in the shape of a girl he would find irresistible … you can guess the rest. These encounters and the subsequent good luck that the Tosher would enjoy in exchange could never be spoken of openly but if you had a child with one grey eye and one blue, like the moods of the river, they would inherit the same good fortune and their hearing would be sharp, as sharp as a rat's.

'Tosher' may of course also be the origin of the word 'Tosh', meaning utter rubbish or nonsense. I can't think of a better root for it, although no one seems sure.

I initially thought that I would juxtapose the old and the new and have London's current skyline rising above the Victorian streets where the Tosher's tale is set, but this proved overambitious and rather jarring so I abandoned the idea. My second issue was that I wanted to include the Queen of the Rats somehow but my early drawings all looked far too cartoon-like and literal somehow, totally out of keeping with the feel I was trying to create. Then I came across an old photograph from the era of a figure standing beneath a bridge with his shadow stretching up against a wall behind him, and it occurred to me how easily that shadow could be that of a rat.

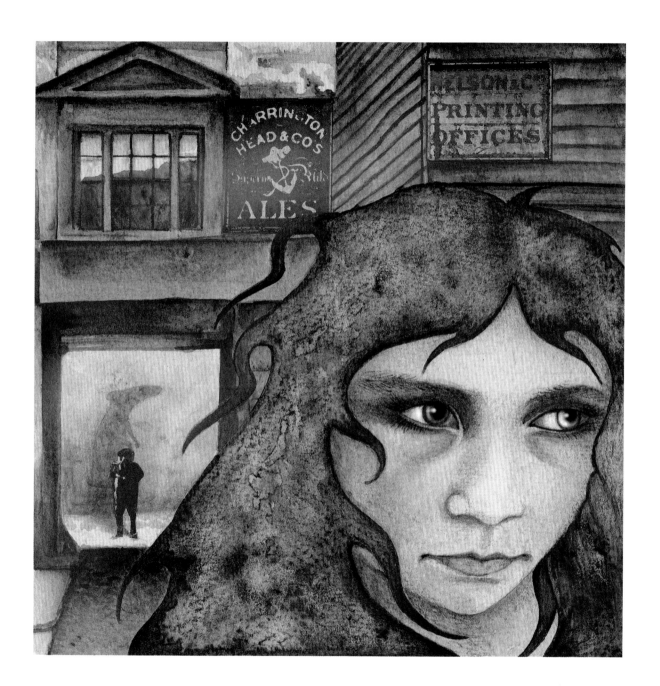

Ceredigion Folk Tales

BY PETER STEVENSON

There have been a few occasions when, on my first read through of a text, something will jump out at me immediately and with such force that I know it will be the cover, even though I have yet to read the rest and I have not even started to make notes. *Ceredigion Folk Tales* was one of these. When I came across this paragraph in the tale of 'John the Painter' I was transfixed:

> And then he saw her. A dignified lady with ivy and rowan berries twined in her hair, cheeks pinched as pink as campion, a flowing gown of red. The Queen of the Fair Folk. 'Who are you, Mortal?' she asked. 'My name is John. I'm a painter,' he replied with a big grin. The Queen laughed. 'We have no need of painters. We are art itself. We are nature. We do not grow old or decay like you. Do you have anything to offer us, Mortal?'

The Queen of the Fair Folk seemed to be looking at me out of the page, but how she should be framed eluded me for a while. I didn't want John the Painter in the picture because in this context we are John, under her appraising eye. I found mention in the text of the Mari Lwyd, and although the natural home of the grey mare is not really Ceredigion, I felt that she could go wherever she pleased and was perfect company for a Welsh queen of fairy folk.

I have always been fascinated by the Mari Lwyd as an object and a tradition and even contemplated making myself a mini version out of a sheep skull I found (I might do it yet!).

To decorate and parade something so resonant with thoughts of death and decay as a skull seems to speak to many of our most ancient fears and desires and there are also many deities in the pantheon of old gods associated with horses, including Epona, the Celtic goddess of horses and fertility, and the strong connection between Rhiannon and horses in the Mabinogion. Dark mischief and the turn of the year seem twinned in so many ways too.

In Wales the fair folk, or Tylwyth Teg, ride out on horses in procession, bestowing gifts on those they favour that will always vanish if spoken of. So here they are together, the grey mare and her queen, as enigmatic as ever, just as we will always want them to be …

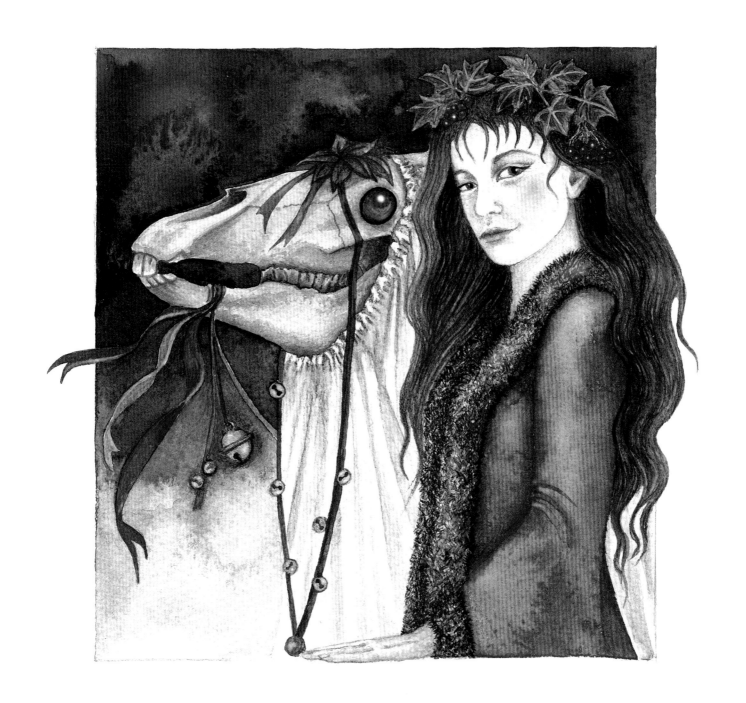

Cheshire Folk Tales

BY THE JOURNEY MAN

The cover of *Cheshire Folk Tales* is my own interpretation of the famed Wizard's Well at Alderley Edge. The legend 'Drink of this and take thy fill, for the water falls by the Wizard's Will' is carved above it, along with an image of the wizard's face. The story tells us that there is an entrance in the rock behind which King Arthur and his knights, accompanied by a white horse for each of them, slumber on, waiting for the call to come to England's aid.

The other story in this book which captured my interest was the tale of 'The Image House', a real place in Bunbury adorned with images of people its owner, Seth Shone, wanted cursed for wrongly convicting him; he made them from clay and displayed them very publicly on the exterior of the home he had claimed squatter's rights to build. This law stated that if you could build a house in twenty-four hours and have smoke coming from the chimney, then the property became yours. Seth completed this and lived in the house until he was wrongly convicted of poaching. Deported to Australia, he served eight years and returned home filled with thoughts of vengeance.

I incorporated some of the images from his house into my version of the well at Alderley Edge, and the wizard is also joined by the horse he trades with the farmer for salt to supply Arthur's last knight with a mount and a Hooden horse from the classic mummers' plays of Halloween … I would have added more as I was getting a little carried away at this point but ran out of time, which is possibly just as well!

Sometimes when I am becoming fascinated by detail I can lose sight of the piece as a whole and have to pull myself up promptly and ask myself whether it hangs together still. This one does, but it could easily have become too fragmentary.

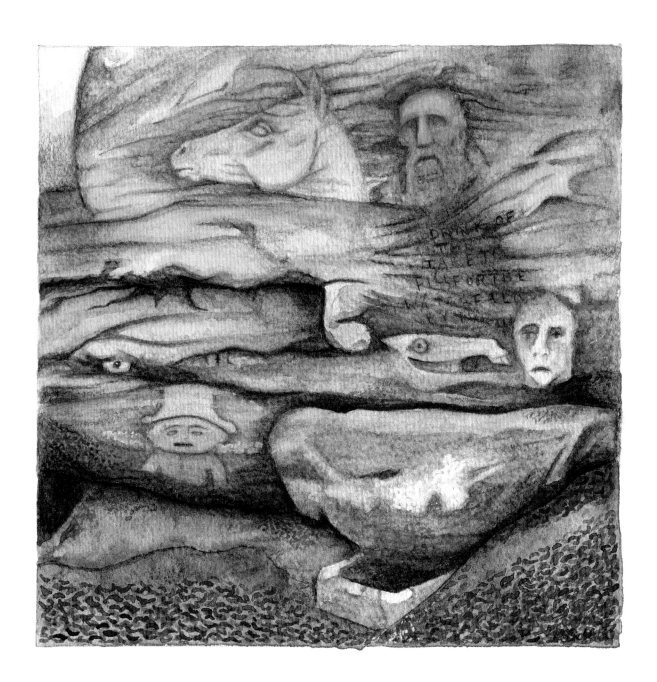

Kent Folk Tales

BY TONY COOPER

The image of a jewel-like serpent writhing in a circle of flames in this particular story was a powerful one, and also one that I have not come across before or since in the Folk Tales series. That the snake then turns out to be a prince of reptiles and promises of rewards from his father, the king, adds to the otherworldly feel of this story, which resolves beautifully when the protagonist is given the ability to understand the speech of all animals. In his introduction to the book, Tony Cooper mentions the difficulty of collecting folk tales in Kent due to its blurred identity: it is a place inhabited by so many different strands of our island heritage but also by those in transition from and to other places. Kent historically played host to many gypsies and travellers in search of work in the Garden of England and I can't help but wonder about the origins of this particular story, for whilst reviled largely by Christianity, much of the world has traditions in which snakes are beneficent beings, as they certainly are in this case:

It was a circle of flames that surrounded something alive that writhed in the heat. Sam blinked his eyes in the smoke and looked closer. There on the scorched grass was a snake with scales that glittered like jewels of blue, green and scarlet. It knotted and shrank from the fire. Now, Sam was a man who had cared for animals all his life – and a snake was an animal after all. He could no more let the snake suffer than he could leave a ewe struggling upside-down in a ditch or ignore a lamb tangled in the bramble thorns. He stretched out his arm and lowered his crook to lift the snake out and over the flames.

This is one of the most colourful and highly stylised covers I have completed and harks back to some of my earlier illustration work, I think it is successful though and gives a sense of the magic of the tale.

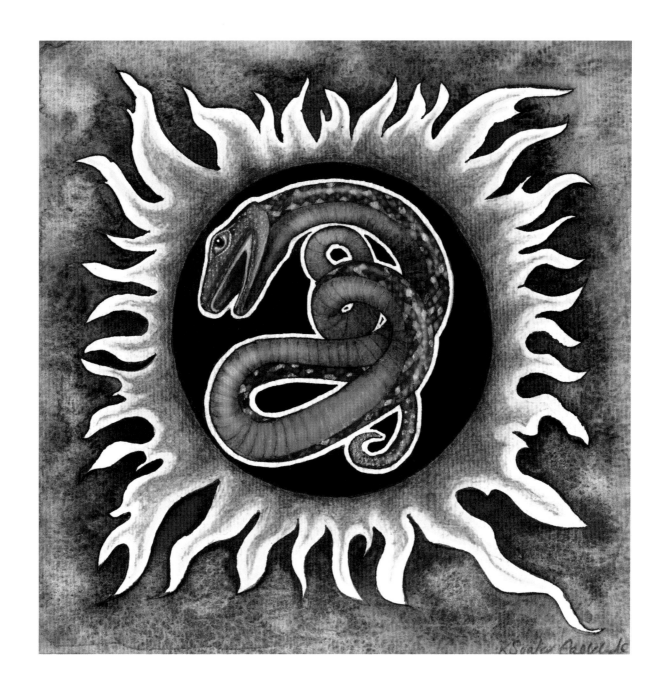

Carlow Folk Tales

BY AIDEEN MCBRIDE

The story of the hairy little pony who appears to have died but miraculously comes back to life as the skinner is halfway through his work sounds macabre, but it has a humour to it that exemplifies for me many of the qualities I love about the tales from Ireland – resilience, ingenuity and a twist in the tale. When the surprised but compassionate skinner sews the pony's skin back on with blackberry thorns the unexpected result is a walking, hairy blackberry plot, seemingly none the worse for the experience:

By Christmas the skin had knitted and healed and there was hardly the sign of a scar on its body. Towards the end of the following spring little bumps began to show where the thorns had taken root under the skin. These had broken into green buds by the end of May. Mick had now got a replacement so the recuperating pony was left to survive as best it could, grazing around the waste ground where it preferred to stay. By the end of that summer the green buds had developed into long healthy blackberry shoots that later in the year had to be pruned by the skinner to give ease to the pony for the coming winter. To cut a long story short, by the end of the following summer that pony sported the finest bunch of blackberry bushes loaded with berries that ever you could see. To everyone's surprise the pony, under this extraordinary load, seemed to be thriving and getting livelier by the day with many years of grazing to look forward to.

In the background you can see a couple of fairy 'raths' atop the hill, these are little clumps of trees on a rise frequently mentioned in the Irish folk tales books as being the domain of the fairy folk, and they therefore feature in the landscape of the covers of several. *Carlow Folk Tales* has a whole section on them and the overriding theme is always that it is best not to interfere with them in any way, lest you anger the fairy folk, which is always a bad thing!

As for the strange stone in the foreground, I honestly can't remember how it came to be there. Sometimes during my wanderings on the Internet while researching a book I will come across something that fits with one of the stories but is not directly referenced and decide to include it. I obviously felt it was needed for the composition to work!

I won't tell you the final twist in the blackberry pony tale – you will need to read the book for that!

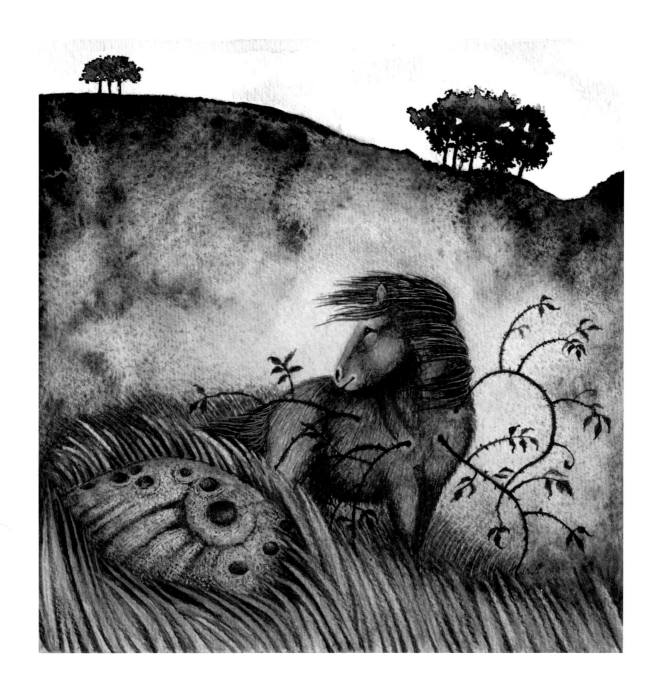

Northamptonshire Folk Tales

BY KEVAN MANWARING

On dark moonlit nights he can be heard – by those foolish enough to wander Fermyn Woods at such an ungodly hour. The Drummer Boy, there he goes – can you not hear above the pounding of your heart? A ghostly rat-a-tat-tat, echoing through the lonely glades of Cat's Head Hill.

Fermyn Woods is home to several chilling tales and this is one of the saddest, the little drummer boy cut down by militia while serving with the Black Watch, who had supposedly run amok in the countryside after being given the cold shoulder by the king. His lonely and rhythmic vigil on the hill seems so sad and poignant. He is only just visible against the sky, which heightens that sense of loneliness, and his insubstantiality is magnified in comparison with the intense colours of the Purple Emperor butterfly in the foreground.

Fermyn Woods is now a popular country park and also the only site in Northamptonshire where the rare Purple Emperor can be spotted. These mysterious creatures live high in the tree canopy for most of their lives so are not often seen – a suitable companion for the solitary spectre on the hill.

The Purple Emperor is a magnificent and elusive insect that is actively sought out by the many subjects of 'His Majesty', as the male butterfly is affectionately known. This butterfly spends most of its time in the woodland canopy where it feeds on aphid honeydew, with the occasional close encounter when it comes down to feed on sap runs or, in the case of the male, animal droppings, carrion or moist ground that provide much-needed salts and minerals. Those that make pilgrimages to see this spectacular creature will often try and lure the males down from the canopy using all manner of temptations – including banana skins and shrimp paste.

The male butterfly is one of the most beautiful of all of the butterflies found in the British Isles. From certain angles it appears to have black wings intersected with white bands. However, when the wings are at a certain angle to the sun, the most beautiful purple sheen is displayed, a result of light being refracted from the structures of the wing scales.

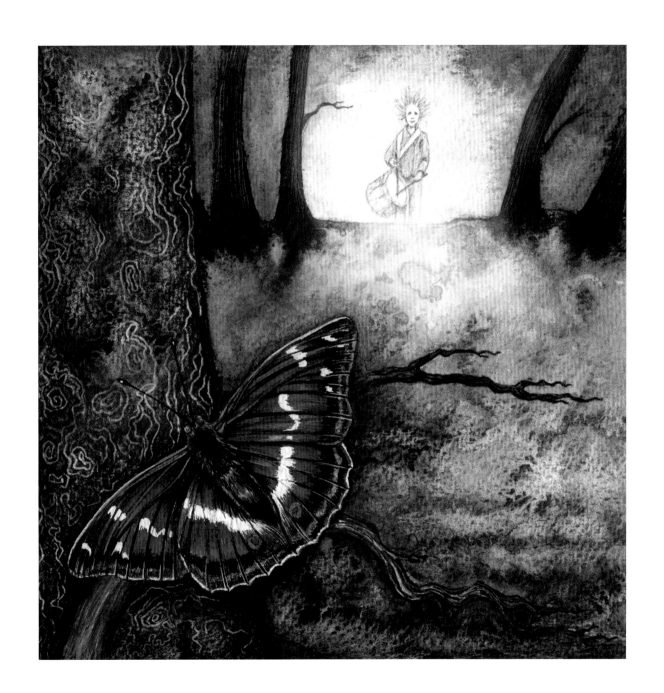

Berkshire Folk Tales

BY DAVID ENGLAND AND TINA BILBE

I have a long-running love affair with the Uffington White Horse. The way this ancient hill figure – the oldest chalk-cut hill figure in Britain at over 3,000 years old – uses so few lines to tell us about the movement of an animal as it runs across the hillside has always captivated me. I remember visiting it on a school trip many years ago and feeling I was in the presence of something the word 'awesome' could be appropriately applied to. In common with many young women, I sat in the eye and wondered whether it would be bring me children.

Until I read *Berkshire Folk Tales*, I hadn't come across the tale of Wayland shoeing the horse and it just seemed too beautiful an idea not to explore. My grandfather was a Master Farrier so I felt I had a direct connection to the story that way too.

Reducing the figure of Wayland to the same minimal number of lines so he looked as though he belonged on that hillside and yet still conveying a sense of what he was doing was quite a challenge. I spent quite some time repeatedly drawing and redrawing them both while referring to photographs of farriers doing their stuff.

As I began the final stage of the painting, with the full moon shining down surrounded by a haze of cloud, the image of Herne the Hunter suddenly asserted himself and appeared there. Sometimes in these pictures, elements almost seem to arrive by themselves, which is why I posted a 'nearly finished' version of this cover without him and then in the finished version, suddenly there he is …

I really like this image, it is one of the simplest of all in some ways but took a deceptively long time to gestate, which is sometimes as it should be.

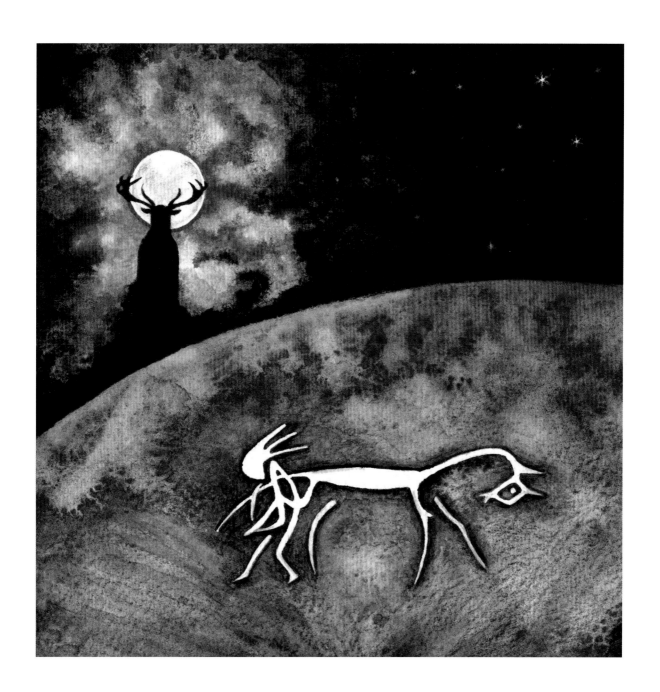

Sussex Folk Tales

BY MICHAEL O'LEARY

One of the most fun covers I have ever completed, in large part due to the hilarious exchanges online between myself and the wonderful Michael O'Leary: author, storyteller extraordinaire, raconteur and very funny chap.

I formed an idea early on that I wanted to emphasise the watery origins of the legendary Knucker, a singular dragon that lived in an almost bottomless pit called the Knucker Hole, and so started researching aquatic lizards and amphibians looking for inspiration. I came across some photographs of axolotl and thought they were perfect casting for the part, with their enormous mouths and horned and feathery external gills, although I was concerned they might be a little too cuddly and lack a sense of menace. I sent some images to Michael and he sent me back a picture of a cuddly toy axolotl … there followed an exchange of pictures, puns and axolotl-related commentary.

'I can make it work, honestly I can,' I insisted.

'Well yes, I think you can,' he said. 'Go for it!'

So the Knucker became an enormous golden axolotl dragon thrashing about in front of Pevensey Castle, with its strange ruined tower that resembles a screaming skull lit with a sickly yellow light that may be the sunset or may be something more sinister.

I still rather want a Knucker all of my own – just a small one, you understand.

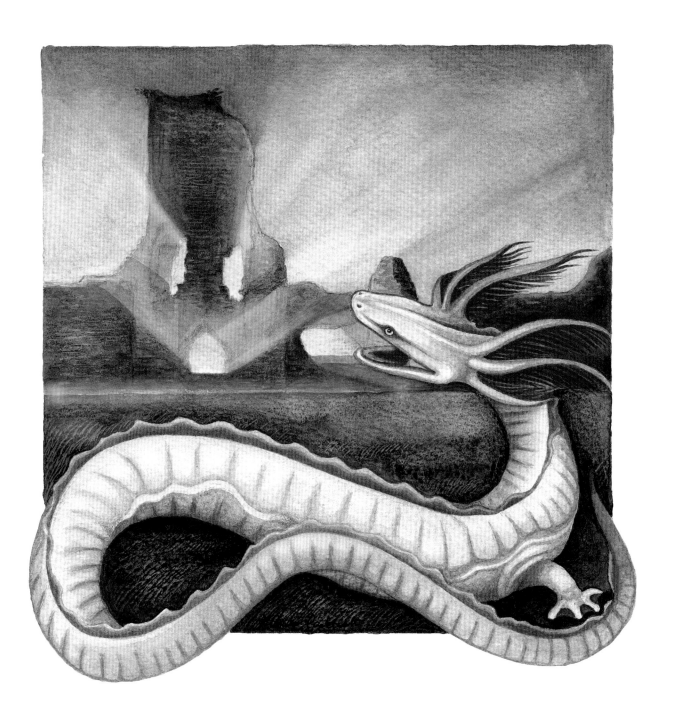

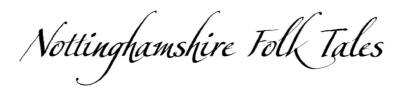

Nottinghamshire Folk Tales

BY PETE CASTLE

I couldn't resist referencing the Goose Fair on the cover of *Nottinghamshire Folk Tales*. I have always had a fascination for fairground art and in particular the carved figures that feature on the old-fashioned 'gallopers' – the merry-go-rounds with brightly painted horses, birds, camels and other exotic creatures that rise and fall to their own music, constantly moving but going nowhere. I loved to ride them when I was a child.

The consensus among historians is that the Goose Fair probably started just after 1284, when the Charter of King Edward I referred to city fairs in Nottingham. The Goose Fair was only cancelled three times apparently, once due to the bubonic plague in 1646 and again during the two world wars in the twentieth century.

It is amazing to think that this event has been happening since the thirteenth century more or less continuously, and it is quite possible that wizards and phantom hounds have visited over the centuries – the legendary Robin Hood could even have wandered around its earliest manifestations too …

This is when you may ask, 'Why not use Robin Hood on the cover? Surely he is more emblematic of Nottingham than anything else?' Well, yes and no; figures like Robin Hood and King Arthur are so important to us as national stories that tales about them crop up again and again in many different regions, the same is largely true of Boudicca. I have avoided using them on the whole for that very reason. I am always in search of something that speaks of the county in particular and is not also common across others. With this in mind, I took the symbol of the Goose Fair as inspiration for the cover and added a fairground version of the Black Dog of Crow Lane, being ridden by the Wise Wizard of Lincoln in his bird form as a black crow.

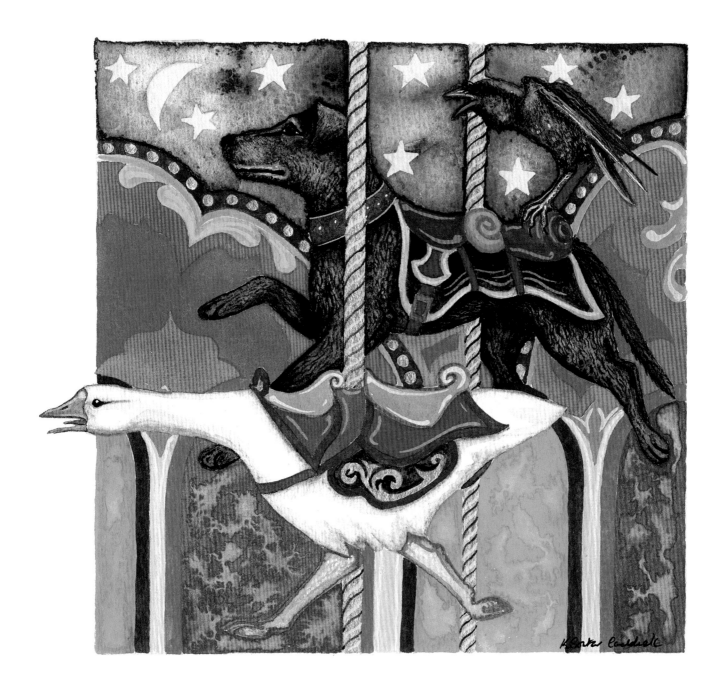

North Yorkshire Folk Tales

BY INGRID BARTON

What becomes of forgotten gods? Do they become the new demons of the world or do they still sometimes appear to us in another guise and in another story?

The Giant of Penhill believed he was the son of Thor, from the old pantheon of Norse gods who were brought to the north of England by Viking raiders over the centuries. He terrorised the people of Wensleydale accompanied by his huge hound, Wolfhead, and his only interest was in his herd of pigs, which were as wild and vicious as he himself. His power was absolute over the people and his cruelty only increased with time. I thought him a wonderful example of power without conscience or compassion and initially thought I would depict him with his fearsome dog and his grim keep in the background. But as I re-read the story I became much more interested in the mysterious figure of the old man and the ravens that accompany him.

It was clear to me that although he is not named in the story, this was Odin the Wanderer (or Woden in Old English), one of the most revered Norse gods and the father of Thor. If the Giant of Penhill was indeed the son of Thor, then it is his own grandfather who arrives to put an end to his despotic reign and punish him for his cruel and murderous ways.

In the illustration he looks on as the giant's keep burns. One of his ravens, maybe Huginn (from the Old Norse for thought) or maybe Muninn (from the Old Norse for memory or mind), keeps him company perching on his staff. Perhaps he feels some sadness as well as triumph, who knows? What is certain is that he saves the children of Wensleydale from a terrible fate, and we should be grateful to him for that.

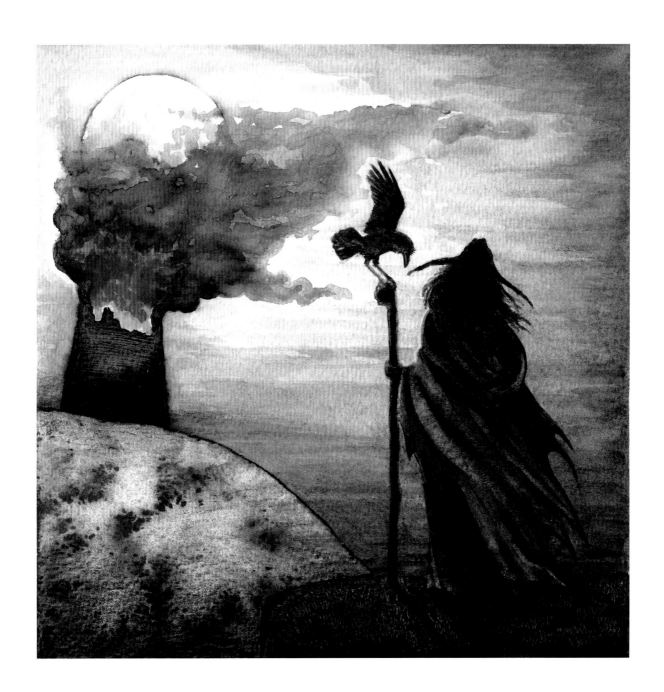

Pembrokeshire Folk Tales

BY CHRISTINE WILLISON

Pembrokeshire Folk Tales was one of the few covers where I was able to use landscape reference photos I already had in my files. I love Pembrokeshire and have visited it often; its quiet places and spectacular views steal my heart as soon as I arrive.

The cover features elements from two stories: 'The Shepherd of Allt Y Goed' and one that at first was a mystery, as I scoured the text and couldn't find the reference to the great boar that was once a king.

'The Shepherd of Allt Y Goed' is a tale of the Tylwyth Teg, the fairy folk, and their habit of leading mortals astray one way or another. In this particular tale it is in the shape of a Draenog, or hedgehog to the non-Welsh among us; it is a classic tale of fairy gifts becoming worthless and of our human greed betraying us yet again.

On the gold comb he peers around is the boar, Twrch Trwyth, named as the son of Prince Tared and cursed into the form of a wild creature; he has poisonous bristles and carries a pair of scissors, a comb and a razor on his head between his ears.

Culhwch is given the task by Ysbaddaden, the giant whose daughter Olwen Culhwch seeks to obtain the comb and scissors from Twrch's head. Later in the story it transpires there is also a razor secreted there. These implements are then to be used to cut and treat Ysbaddaden's hair.

Interestingly, this story does not actually appear in the final copy of the book, which explains why I spent some time searching for it in vain when I was about to write this text, only to be put out of my misery by the author.

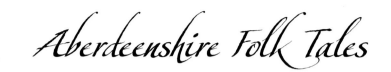

Aberdeenshire Folk Tales

BY GRACE BANKS AND SHEENA BLACKHALL

This illustration, so full of detail and yet so sparse in colour, was inspired by one of the most disturbing and visceral themes in folk tale – the murder and consumption of children by adults. It was the first time I had come across this tale of murder, transformation and revenge but I have since read another version in *Dumfries & Galloway Folk Tales* and most startlingly have also come across it in the Moroccan Sahara as a tale told by Saharaoui nomads. The story was published by the Brothers Grimm as 'The Juniper Tree' but the Scottish and Moroccan versions are much closer to each other than to the Grimm version and I am intrigued by the connection and plan to explore it further at some point.

All versions of this story share the same characteristic of a bird reincarnated from the child's bones, which sings a song telling of its betrayal and murder in order to collect the various items that it uses to revenge itself and reward the virtuous. Here is the Aberdeenshire version:

> My Mammy killed me,
> My Daddy ate me,
> My sister Jeannie buried my bones
> And covered me up with the graveyard stones,
> And I flew and I grew,
> Tae a bonnie White Doo-oo.

Several things stood out for me in the Aberdeenshire tale, including the fact that the stepmother is able to convince the child's father that his daughter's death was an accident, but she never explains why she then cooks her for dinner, which seems an incredibly weird and abhorrent thing to do!

Another is the way the child is then allowed down from heaven by St Peter in the shape of a dove to exact a very brutal and bloody revenge on her stepmother using a knife made by her own husband. This is not only marvellously vicious in a way that defies any angelic characteristics that we usually attach to a heavenly dove, but also gave me a chance to create an image juxtaposing the knife and dove and leaving people to draw their own conclusions as to their relationship before reading the story.

The knife in the illustration is of a traditional Celtic design that would be forged by a blacksmith from a single piece of iron. The only colour is in the few drops of red blood hinting at the use to which it has been put.

Grace Banks commented: 'We were really surprised that you chose this story! And even more surprised that it gave rise to such a beautiful image.'

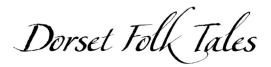

Dorset Folk Tales

BY TIM LAYCOCK

This cover is another where I struggled to settle on one story and ended up using elements of several. This seems to happen sometimes and usually it works out well, although I always have a nagging feeling they are a little unfocused as a result – you will need to judge for yourself.

'Jack and the Boat' is the first story: three brothers are given tasks and inevitably the youngest is the only one with sense enough to make a success of them:

> Then the Old Lady told Jack that the boat was a magic boat. If he got in and sang that old sailor song 'Hooray and Up She Rises', the boat would rise up and fly North, East, West and South. It could go under the sea like a submarine or up into the sky like a spaceship. It would even go back into the past or forwards into the future – wherever he told it to go.

So yes, a flying boat, so much more attractive than a DeLorean for time travelling, I think!

The horse in the lower right of the cover is from a brilliant story of a boy and his father outwitting the magician 'The Old King of Corfe' through some clever shapeshifting, using one of his own devices against him:

> This time, I shall turn myself into a racehorse with a red leather bridle hung with golden bells. Take me up to the race course and ride me around. Everyone will want to buy me, but don't sell me to anyone except the Old King of Corfe, and when you do sell me, don't sell the bridle; I will be that bridle, and once he has gone I can turn back into myself.

Then I could not resist a nod to Mary Anning, the famous fossil hunter who scoured the beaches of Dorset in search of gigantic seagoing reptiles from our planet's distant past, some of which I have visited and drawn in the Natural History Museum. So I included the skeleton of a plesiosaur, one of her famed finds.

Finally, 'The Dorset Ooser', a curious and grotesque figure that appeared at cottage doors on Melbury Osmund every Christmas, sits silhouetted against the sky. His head, carved from wood, has staring eyes, matted hair, a great clomping mouth full of discoloured teeth, and a huge pair of bull's horns. Carried on a short pole by a man hidden under a long cloak, it must have made a terrifying impression on anyone seeing it through a dimly lit cottage window for the first time. The poet William Barnes knew of the Ooser, and surmised that the name was a corruption of 'the Worse One', meaning the Devil.

Shropshire Folk Tales

BY AMY DOUGLAS

The story of a lonely young man who can't bear to kill a beautiful salmon he catches one day from his coracle on the River Severn and is then followed home by a beautiful woman who definitely has something of the fish about her, was one I was drawn to immediately. I live by the same river, just a mile away from the famous iron bridge, and coracles used to be a familiar sight there. I know that for many Shropshire is about the hills and wild places haunted by Edric and his terrifying hounds, but for me it has always been about the river, its moods and its mysteries.

It seemed right to have the image set during the night hours; I imagined the salmon woman returning to her beloved river from time to time while her family slept and remembering what it was like to have the freedom of Sabrina's waters. I often sit alone on the riverbank and listen to the waters swirl past, spiralling and surging through the gorge on their way to the distant sea, where a salmon too would one day go if she were not married to a mortal.

If you read the story you will also notice that I changed her hair colour from blonde to black, as it somehow worked better for the picture. I don't think she would mind ...

Author Amy Douglas said the following:

Working with Katherine is a delight as she has a genuine love and delight in traditional folklore and story. She has been a supportive devotee of storytellers and storytelling for as long as I've known her, including being a vital member of the Festival at the Edge team for many years. When I knew she was going to do my front cover I was delighted ... authors usually don't get a say with sometimes disastrous results. I sent my proofs to Katherine and she instantly honed in on the story I thought would be her favourite, mine too and absolutely the one that I wanted on the cover.

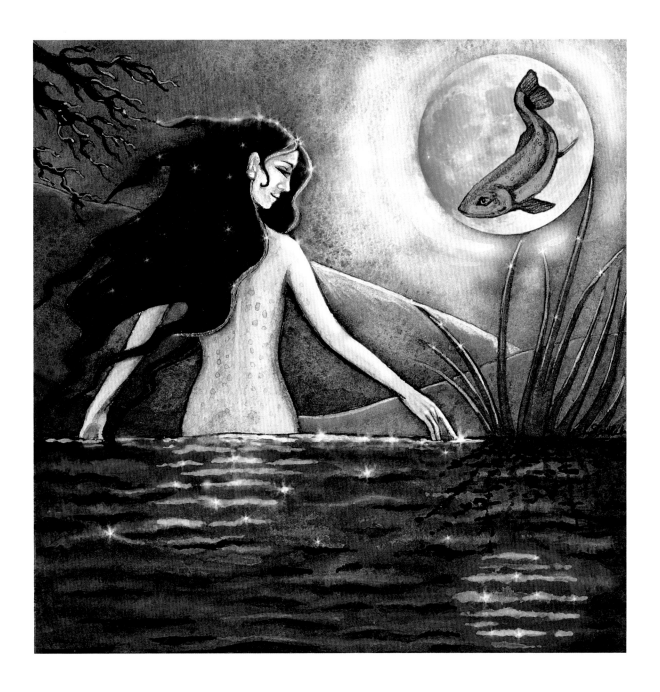

Armagh Folk Tales

BY FRANCES QUINN

It is not often that I am gifted with an image so complete, so wonderful and so unusual as the one that leapt from the text of *Armagh Folk Tales*. The story is entitled 'The Death of Fergus Mac Leide' and Esirt, chief poet of the Lepra, has just assured his fellow poet Aed, who is from the court of King Fergus and is wondering how they will cross the sea to meet King Lubdan, that the king will send his steed to collect them:

> After three days and three nights Esirt set off for his own country accompanied by Aed, the poet, who had volunteered to go with him. When they reached the sea Aed wondered how he would cross it but Esirt assured him that King Lubdan's horse would bear them over the waves. Then Aed saw a hare with a bright red mane approaching them through the foam. It had four green legs and a long, drifting, curly tail and its bridle glittered gold and its eyes flashed fiercely. Aed was loath to mount such a creature but Esirt reassured him and the two sped across the waves on the steed of Lubdan, King of Lepra and Leprechaun.

How could I resist this amazing creature? I love hares and this was a hare with more magic attached than any I had so far come across. Despite his outlandish appearance, he is no giant amongst hares though. The poet Esirt is one of the little people, as is his fine and honourable king; any of them could stand on the palm of Aed's hand and Aed himself could stand on the palm of any of the Warriors of Ulster as he is tiny among humans himself. The Lepra were tiny, but the Leprechaun tinier still and Lubdan was King of them all.

This is one of my favourite stories; originally written in medieval Irish it is often thought to be a satire on the Warriors of Ulster and, despite its title, is really all about King Lubdan and his adventures.

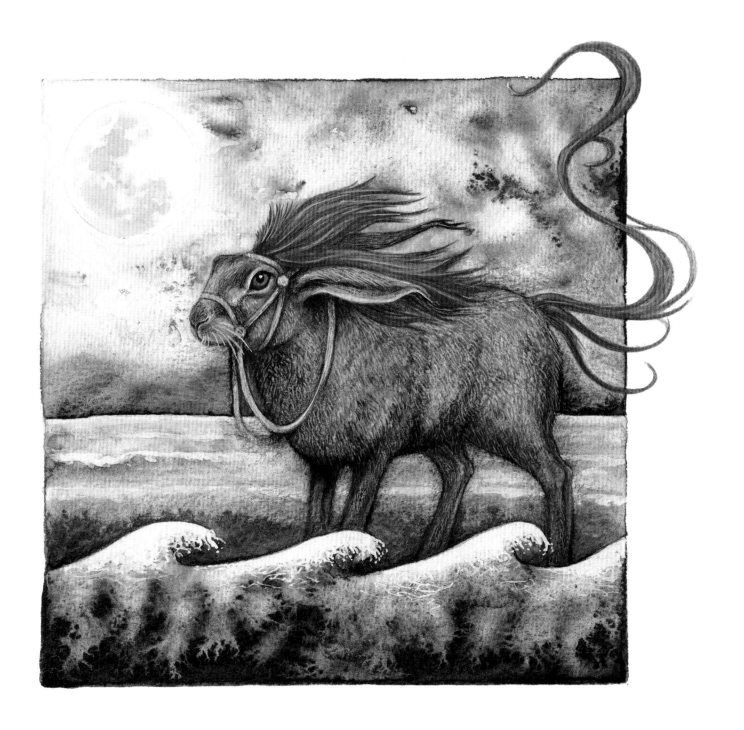

Lincolnshire Folk Tales

BY MAUREEN JAMES

And so she grew up, with little to eat or wear, spending her days in the fields and lanes, with only the gooseherd for a companion, who would play to her so merrily on his little pipe, when she was hungry, or cold, or tired, that she forgot all her troubles, and fell to dancing, with his flock of noisy geese for partners.

The tale of 'Tattercoats' is a particularly Lincolnshire take on the Cinderella story, the protagonist in this case being free to roam in her world of fields and lanes with her friend the gooseboy after her father, possessed by grief at the death of her mother, takes no interest in the child and leaves her to fend for herself.

And here she is, dishevelled but certainly not despairing, running free with geese for company.

She does of course eventually meet a charming prince, who promptly falls in love with her, even in her scruffy state – perhaps because he sees past the superficial – or perhaps because of the sweet pipe-playing of the goose boy, or fairy goose father as he seems to be cast in this case.

She, however, is not convinced at first:

'You would be finely put to shame if you had a goose-girl for your wife!' said she. 'Go and ask one of the great ladies you will see tonight at the King's ball, and do not flout poor Tattercoats.' But the more she refused him the sweeter the pipe played, and the deeper the young man fell in love, till at last he begged her, as proof of his sincerity, to come that night at twelve, just as she was in her torn petticoat and bare feet, to the King's ball with the herd boy and his geese; he would dance with her before the King and the lords and ladies, and present her to them all as his dear and honoured bride.

I really hope they lived happily ever after …

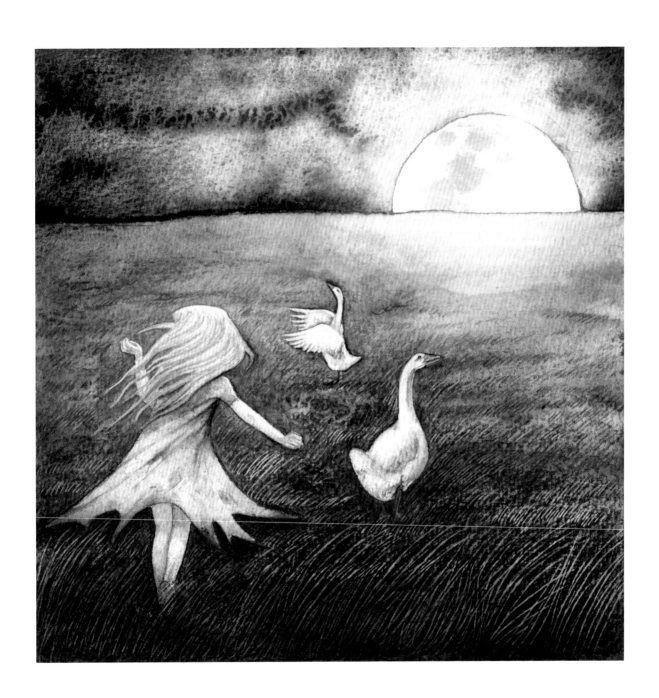

Suffolk Folk Tales

BY KIRSTY HARTSIOTIS

I used to visit London frequently and one of my favourite ways to pass an afternoon was to go to the British Museum and spend hours in just one or two of the galleries, sketching or just gazing at the beautiful human things and imagining who made them and how.

The first time I saw the Sutton Hoo helmet I could only stand and gape foolishly … it is one of the most stunning objects I have ever seen and for me its beauty lies as much in its decay as in its conception and craftsmanship, and I find the bright new reproduction a little soulless by comparison.

So when I received the manuscript for *Suffolk Folk Tales* by Kirsty Hartsiotis and there was mention of the helmet in it, my heart leapt. Unfortunately, it didn't actually feature in any of the tales as such, so I searched for a way to blend it with another story in the book in a way that would enhance them both.

'The Green Children' is a curious story which is presented very much as a true account, although explanations of the children's colour and origin vary. Whatever you choose to believe, it is a fascinating tale of the discovery of two otherworldly lost souls taken in by the populace of the settlement at Woolpit.

The idea of having one or both of the children peering through the helmet appealed enormously, making that eye socket a window between worlds, like the museum I love so much. In the end I used the little girl's face for maximum impact and just a small section of the helmet around the left eye socket in detail. I built this illustration up very slowly. The child is entirely rendered in Inktense and the helmet in watercolour and coloured pencil, with considerable deployment of my embossing tool to add texture and depth. It was a labour of love, this one, and I almost didn't want to finish it.

Kirsty said the following:

Words can't express how much I love this image, by some astonishing telepathy, Katherine had managed to pull out from the book the two tales/places that had the most meaning for me: the story of the Green Children, known to me since I was a tiny girl, and Sutton Hoo, which I fell in love with as a student of Anglo-Saxon stuff in my early twenties.The cover, for me, couldn't have been more perfect. I still find the Green Girl's face as captivating each time I look at it as the first time I saw her. Katherine's captured that sense of wistfulness, distance and otherworldliness that I hope I captured in her story, and to have that combined with, mediated through the rusting glory of Suffolk's distant past, a shadow land of saints and monsters wrapped up in the tale of that one burial is truly wonderful.

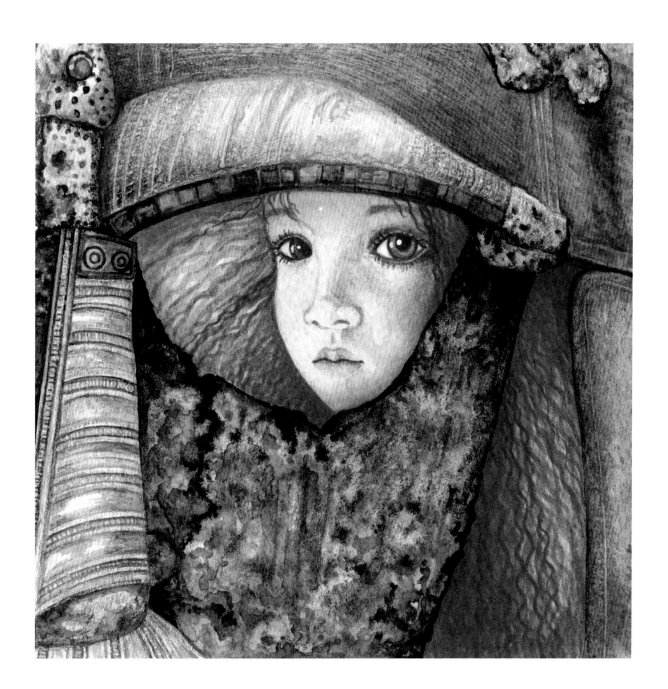

Meath Folk Tales

BY RICHARD MARSH

The cover for *Meath Folk Tales* features the Salmon of Knowledge: there is a reference made in the book to it dwelling in the Trinity Well at the foot of Carbury Hill in County Kildare before being caught in a pool of the River Boyne, Linn Feic, near Rosnaree.

I was very attracted to the idea of depicting the salmon living alone in his well and began to do some research on the story which deepened my interest, and also the mystery.

During my research I came across the image of the salmon living in a holy well overhung by nine hazel trees from which nine magical hazelnuts of wisdom drop shining into the dark water, to be eaten by the lonely fish, making him famously the carrier of all wisdom. He is later caught and killed by Finegas, who believes he is destined to acquire this wisdom, and asks a young boy to prepare the fish for him but not to eat it, but the boy burns his thumb in the process and instinctively puts it into his mouth so in the end it is Fionn Mac Cumhaill, who accompanies Finegas, who eats the salmon, giving him the gift of prophecy.

The image of the well and its trees and solitary fish is a very seductive one for an illustrator and I immediately had an idea for how I wanted the composition to look. I decided against using any kind of realistic proportions as I wanted to show the whole of the well but also have the salmon the dominant feature. So, the trees and well are small and stylised in order to give him and his hazelnuts pride of place in the piece.

The mystery is that there is some dispute amongst folklorists about whether the Trinity Well was indeed the first home of the salmon, for the Shannon Pot which gives rise to the River Shannon may also have some claim. And I have been told there is dispute over the number of trees bearing the hazelnuts of wisdom too … but wherever the salmon lived, and however many hazel trees overshadowed it, he is a very special and evocative creature.

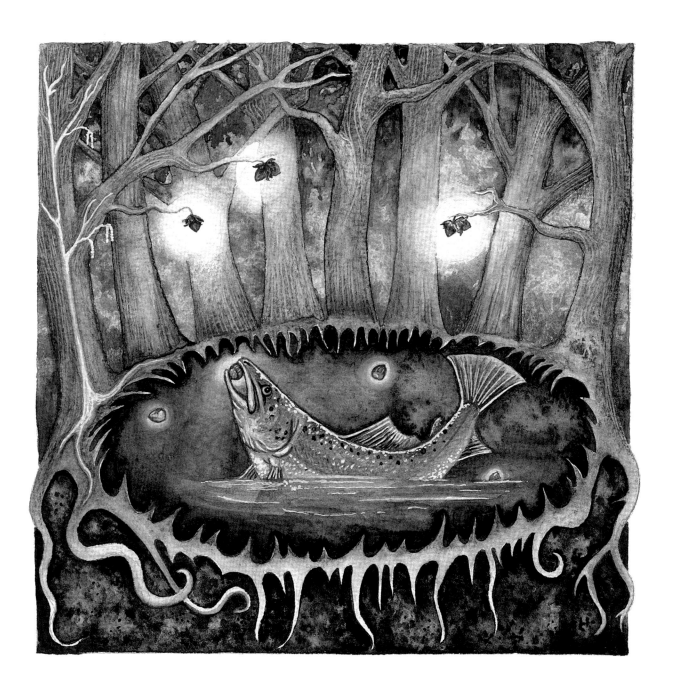

Snowdonia Folk Tales

BY ERIC MADDERN

When I started to read the manuscript for *Snowdonia Folk Tales*, I did something I often do if the author is someone I am in contact with – I sent Eric a message, asking if he had any preferences as to what the cover story might be. He was busy and didn't reply for some time.

I had read the book by then and had found the story of Blodeuwedd, one that I already had a fascination with as I had read *The Owl Service* by Alan Garner when I was young. I also watched the excellent TV adaptation, scripted by Garner himself, when it was repeated in 1978; I would have been fifteen then and at an age for it to make a lasting impression on me.

I wanted to work with this story very much; I felt a connection not only with the woman of flowers but also my own teenage self that could be expressed through this image.

I started to make sketches, trying to work out how to depict the flower and owl aspects of a character I felt was more sinned against than sinning. This was a grown woman released upon the world fully formed and filled with desires and feelings she had no experience of regulating, as she had not grown from a child to an adult. A woman created for a purpose she had no choice about. She was made from wild things and was then expected to be tame.

While I was trying to find the face of my woman of flowers Eric replied to my message, suggesting her story would be a good one to choose. I love it when this happens, and it has happened several times with this series.

I didn't want to make an image melding the woman and owl aspects. I had seen many of these and somehow they seemed brutal to me; I felt that, although her transformation is a punishment, it is also the moment she is set free back into the wild and able to express herself without regret.

The fact that she becomes an owl, a creature regarded throughout history and across many cultures with fascination and awe, seemed important to me.

Few other creatures have so many different and contradictory beliefs held about them. Owls have been both feared and venerated, despised and admired, considered wise and foolish, and associated with witchcraft and medicine, the weather, birth and death. Speculation about owls began in earliest folklore, too long ago to date, but passed down by word of mouth over many generations.

In the end I decided to have the owl blending with the background behind Blodeuwedd, a fate that awaits her in the future as she wakes in her bower and looks out directly at us with eyes that, although they have only just opened on the world, are full of self-awareness. One day she will return to her woodlands as an owl, but now she is about to enter our world, one whose rules she does not know and will never really understand.

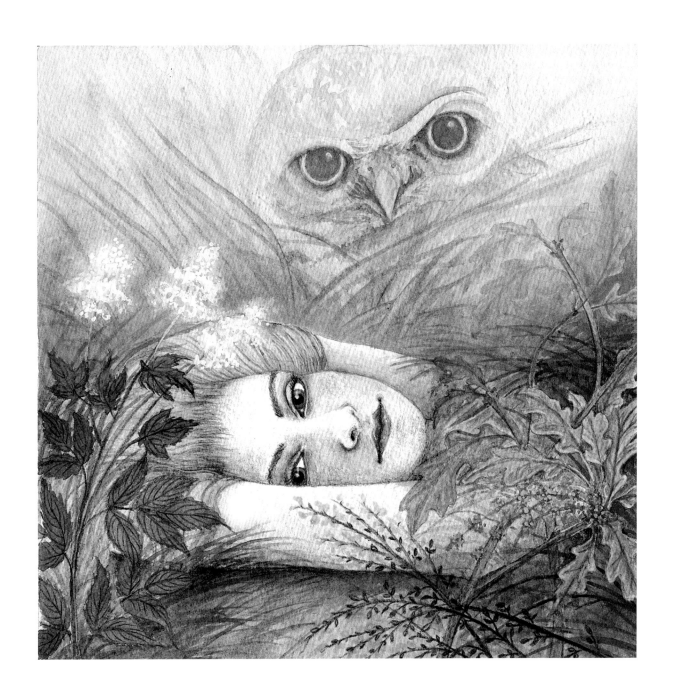

Essex Folk Tales

BY JAN WILLIAMS

I have always found scarecrows a little sinister; something about their lonely vigil and their odd silhouette against the sky is unsettling. Mawkin, the Essex name for them, seems to fit very well with this image. The story in *Essex Folk Tales* of a scarecrow coming to life and demanding the coat from a terrified poacher's back gave me a chance to explore the macabre aspects of one for myself.

Sam stands in a field ready for harvest, a time of death and plenty in the countryside. As the wind rises and the sky presages a late summer storm:

he heard a rustle by the stile and knew something was moving in the barley field. He looked over and saw the mawkin. He was convinced it had moved, but for the moment it was totally still. The widow must have moved it in the night. But suddenly, to Sam's horror, he was looking right in the mawkin's face. It was not a pretty sight. There was something about the tattered and stained dishcloth making the face, and burst holes making the eyes, that filled him full of dread. His stomach tightened with fear and he tried to crawl into the undergrowth but he could still see that mask-like face staring at him. Then came the voice – the strange, strained voice of the mawkin. 'Hoo, Ho, Muster Knowall, d'ye gi'eme your coat, Muster Knowall. I'm acowld. I'm a c-cowld.' Gradually the voice was growing deeper and more threatening. The demand for a coat was now being backed by the threat of turning Sam into stone with the use of his crooked stick. Sam was paralysed by fear. The stick seemed to be getting closer and closer to him. 'I'll gi'e ye. I'll gi'e ye,' he squealed. Pulling off his coat desperately, Sam flung it over the fence with the rabbits still bulging from its pockets.

As the only story featuring a scarecrow in all the Folk Tales books I had read so far, it seemed worthy of an image. There are many recurring themes in English folklore particularly, making the ones unique to an area really stand out.

On a rise in the background is the ruin of Hadleigh Castle, mentioned in the story 'The Heart of Thorns'.

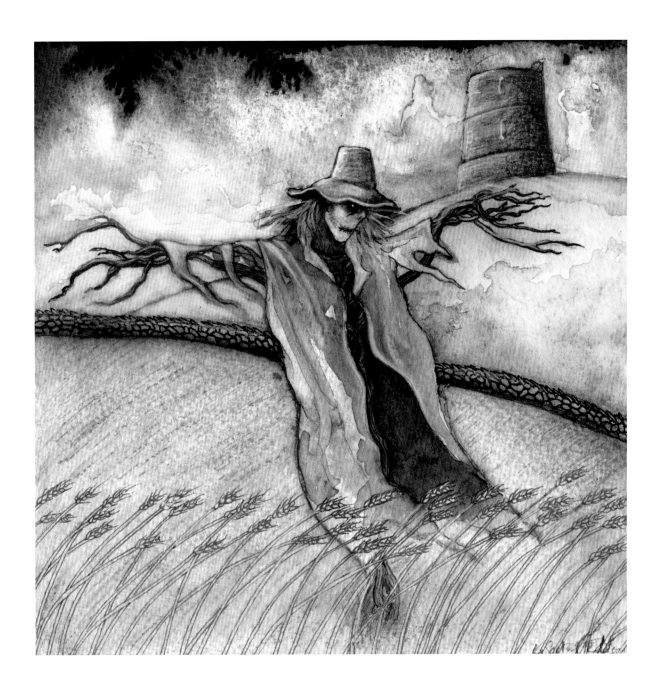

Cavan Folk Tales

BY GARY BRANIGAN

There was a note attached to this text asking if I would consider the tale of Finn Macool's Fingers for the cover illustration, so I went straight to this story to see what it held in the way of imagery:

> Following this, the Fianna sounded the war cry, the famous Dorn Fiann, by blowing their horn, the borabu, three times, and charged towards Cairbre's men. When the two armies clashed, there was such ferocity that the ground trembled and sparks flew from their swords. It is said that on that day the plain of Gabhra ran red with blood and the mighty river that once drained the lands of water now drained it of the blood of the fallen warriors.

Finn loses everything in this battle: family members, comrades and finally the battle itself.

He places a standing stone on the battlefield and picking up the horn, retreats, grieving, until he reaches the entrance to the otherworld in Breffni. Entering the cave, he vows that when Ireland needs help, sounding Dorn Fiann three times will bid him and his men rise once again to protect the land. He then pushes his hand through the ceiling of the cave and falls into a deep slumber. Over time the sun has bleached his exposed fingers and turned them to stone. They can be seen to this day on Shantemon Mountain.

I read the rest of *Cavan Folk Tales* and there were many good stories, but the image of Finn's bleached stone fingers and my curiosity about this great war horn that actually had a name brought me back to the story the author had highlighted.

Images of the famous stones were easy enough to find and they did look eerily like fingers pushing up through the earth and grass. But what would that horn have looked like? No one seemed totally sure, archaeological evidence for Irish war horns was mostly of quite small instruments, they didn't seem impressive enough to announce a battle or to have a name all of their own. But my searches did keep throwing up the Carnyx, an ancient Celtic horn which is enjoying something of a revival, with new ones being made and even played today. Now this was a horn that deserved a name and could be heard across a battlefield. They often had a boar-shaped head, which also resonated with other ancient Irish stories I knew: it was the perfect second element to the composition. I used some artistic licence for this particular version, but then artists would have shaped these things and I have shaped my own here.

When I had all but finished I noticed there was a space. Sometimes space is fine and gives balance to a composition, but this one was definitely waiting for something to arrive in it. I went back to the text and found the story of the old woman and the hare. Stories of shapeshifting into hares abound in folklore, and often end badly for the women involved. I chose to have her rest in the shadow of the stones – perhaps one day she will also be restored and choose to leave people's cows to themselves this time.

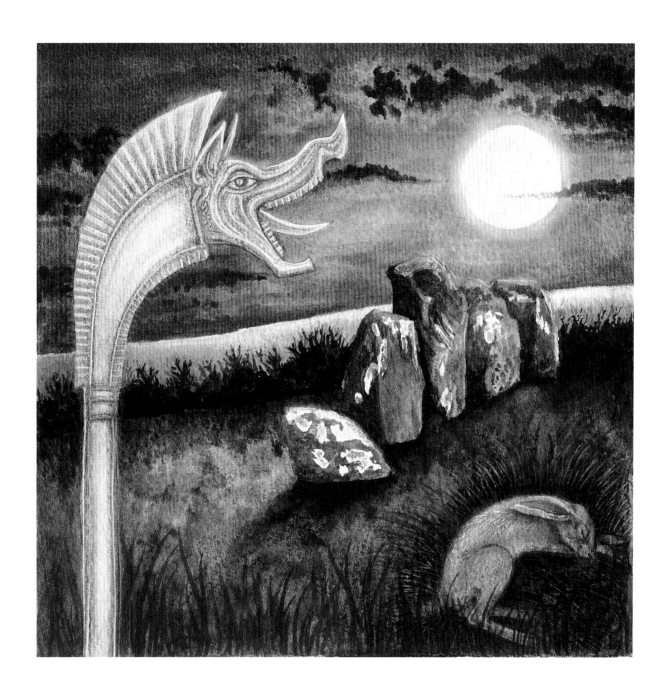

BY SHARON JACKSTIES

There is something strangely beautiful but also rather sinister about pollarded trees, and pollarded willows are such a feature of the Somerset Levels that I felt one needed to be on the cover of *Somerset Folk Tales*. The stories of these strange curtailed trees dragging the unwary traveller to a watery grave inspired the grim image in the water, where we see the more evil aspect of the tree reflected.

The cranes flying overhead through the mist, through which we glimpse St Michael's Tower standing vigil atop Glastonbury Tor, reinforce the feeling that the Levels are a place eternal and a place of water always. I didn't know their connection to story lore at the time but they seemed needed, something that quite often happens when I am thinking about elements to include in my images.

Water makes up such a huge part of our world, and of all of us, and without it we are nothing but dust. Maybe that is why I am drawn back to it so many times in so many images.

Author Sharon Jacksties had this to say:

Katherine's cover captures the distinctive landscape and atmosphere of the Somerset Levels. Hollow willow trees are a major feature and have given rise to a legend which is connected to the tradition of Jesus' family visiting this part of the country. I was especially moved to see that Katherine had included a pair of cranes, as these magnificent birds have recently been successfully reintroduced. A symbol for story lore amongst ancient Britons, wild cranes were also joining their protected kindred as I was writing this book. Mentioned in just two sentences, I was so touched that Katherine had chosen to depict these symbols of storytelling and its revival.

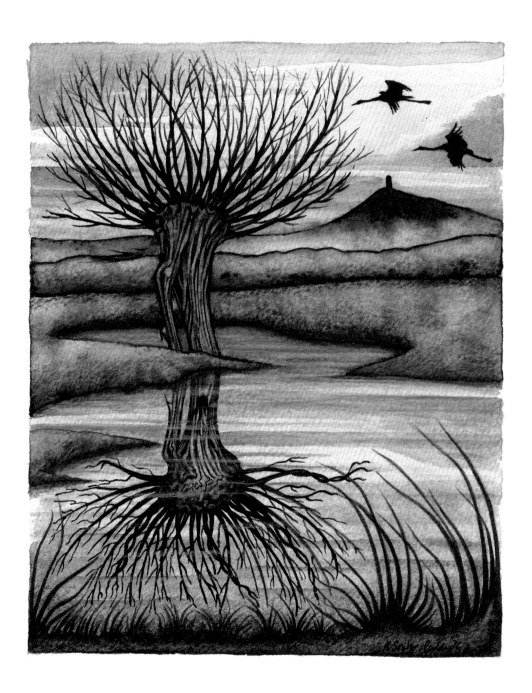

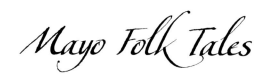

Mayo Folk Tales

BY TONY LOCKE

The County Mayo coat of arms has upon it nine yew trees, one for each barony of the county. The name Mayo is anglicised from the Irish *Maigh Eo*, meaning 'plain of the yew'.

The main feature of this cover is the yew tree, a living being that bestrides the past and present like few others as it is so long-lived and can even be considered almost immortal with its unique growth pattern, in which its branches grow down into the ground to form new stems, which then rise up around the old central growth as separate but linked trunks. After a time, they cannot be distinguished from the original tree. So, the yew has always been a symbol of death and rebirth, the new that springs out of the old.

This section of yew lore from *Mayo Folk Tales* is particularly lovely:

When the yew was a young species, in times when there were few people, it thought that all other trees were more beautiful, for their colourful leaves could flutter in the wind unlike its stiff pine needles. Thinking that the faeries had deliberately made it unattractive the tree pined. However, the faeries wanted to please the yew, and it woke one sunny morning to find its needles had changed to leaves of gold and its heart jumped with joy. Some thieves came and stole the leaves, making the tree confused and sad. So the fairies tried again and gave it leaves of pure crystal and the yew loved its sparkle, but a storm of hail came and the crystals shattered. Then they gave it broad leaves and it waved them in the air, only to have them eaten by goats. At this the yew gave up, for it realised that its original dress was by far the best, for it was of permanence, of long ages and deep knowledge, and in this the tree found comfort.

I was also taken by this little snippet about Inishkea:

The Island of Inishkea was named after a woman called Kea who founded a small community of nuns on the Island. However, the inhabitant that I wish to tell you about is a magical crane. It is said that he has been on the Island since the beginning of time, perched high upon a rock looking out over the Atlantic Ocean. He keeps a lonely vigil; never visited by any of his own kind he ignores all other birds. Life passes him by like a fog drifting in from the sea and folklore tells us that he will continue his vigil until the end of time.

So into the background went the lonely crane, to continue his vigil on the cover of *Mayo Folk Tales*, which is only right I think.

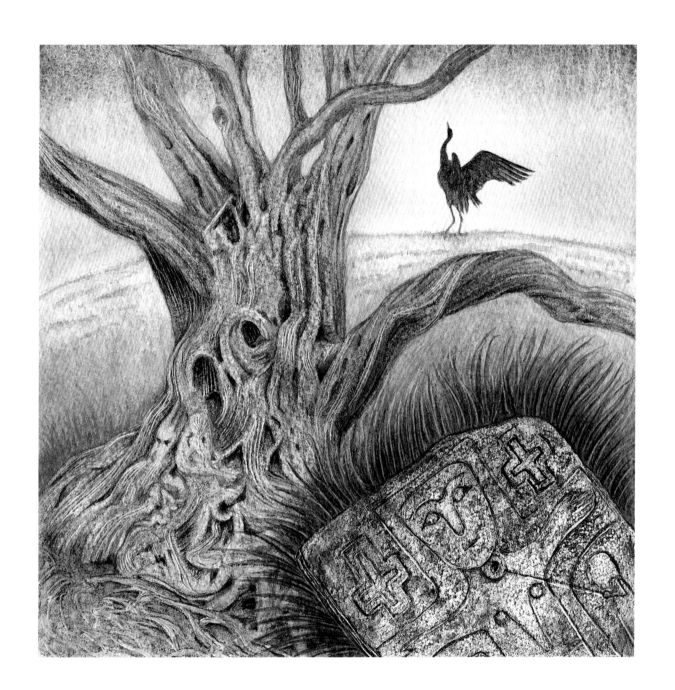

East Yorkshire Folk Tales

BY INGRID BARTON

On 10 April 1733, a man leapt from the top of the steeple of Pocklington parish church. He was Thomas Pelling, the Flying Man. A rope had been attached to the top of the tower, with the end wound into a windlass near to the Star Inn on Market Street. Straps had been inserted into iron rings on the rope and wrapped around Thomas' chest and one leg, leaving his arms and one leg free for balance. He was also wearing a set of wings, designed to make him look like a bat.

An eccentric choice of activity, perhaps, but flying men were a popular form of entertainment at the time. It is likely that Thomas Pelling was in Pocklington to exhibit as part of a fair or market. Unfortunately for Thomas, as he began his descent the rope became too slack. He called out for the windlass to be tightened but his instruction was misunderstood and the rope was loosened further. The Flying Man plummeted onto the battlements at the east end of the chancel and fractured his skull. He died two days later, and was buried at the exact spot he fell. A memorial plaque commemorates his final flight.

When people ask me why I choose a certain story for the cover of a book, I often reply that one of the things I look for is something unique to the area, partly because – in England at least – there are many stories that have variations that appear in several counties or may even have come into an area from somewhere else, so it is always satisfying to find a tale with a strong local connection. They have a 'flying man' festival in Pocklington to this day.

The craze for flying in the 1730s was something I had been hitherto unaware of. Men, boys and even a donkey (although I doubt it was the donkey's choice) risked life and limb 'flying' between tall buildings for the entertainment of the crowds. Unfortunately, the life expectancy for flyers was not long and this dangerous entertainment disappeared within twenty years or so.

Finding someone falling in the right sort of way from which to draw from proved quite a challenge and I eventually worked from several different sketches and silhouettes to try to get the figure right. The smudge across the sky as he falls is achieved by using a water-soluble pen to outline his shape before I painted him in and then wetting it and lifting the paper, a bit like the chromatography experiments we all did in school.

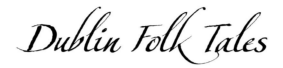

Dublin Folk Tales

BY BRENDAN NOLAN

This strange and almost blackly comic tale from the city of Dublin was the first of the Irish titles I received and it really caught my imagination.

Dublin in the 1800s was (and indeed still is) a feisty and vibrant city, but was terrified for an entire winter by a sort of 'werepig' thought to contain the unquiet spirit of a man called Olocher, who, condemned to death for the rape and murder of a young woman, took his own life in the Black Dog jail to cheat the hangman's noose.

Soon afterwards a watchman was found unconscious outside the jail. When he was revived, he was found to be paralysed on one side of his body and he claimed that he had seen an apparition in the shape of a black pig. For many nights afterwards, the black pig was seen by several other sentries. Later, a warder at the Black Dog disappeared and his clothes were found draped over his gun.

And so the legend of the Dolocher began: several women were attacked and ladies all over the city became afraid to walk abroad at night for fear of the dreadful black pig that stood upright. Some locals even went on a pig-culling spree in an attempt to root out the creature (Dublin being full of semi-feral swine at the time), until one night the Dolocher chose the wrong victim and the mystery of the guard's disappearance was suddenly solved too.

So, where was I going to get a model for a werepig? I tried drawing one from imagination but it didn't look quite right somehow and had a tinge of the Beatrix Potter about it, which wouldn't do. So I persuaded my long-suffering spouse to pose in a suitable stance and used him as my Dolocher model. I loved the idea of the shadow cast being huge, a reminder that the story here is so much bigger and scarier than the actual truth. But it is still one of the best yarns I have ever read, and author Brendan Nolan told it very well.

K Sarah Caddick.

Orkney Folk Tales

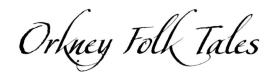

BY TOM MUIR

One of the things that drew me to the story of 'Stronsay' in *Orkney Folk Tales* was that here was a passionate and headstrong woman who does what she wants and, unusually in folk tales, does not get punished for it. Bold women can fare badly in traditional tales at times and I am always happy to find one who doesn't.

'What do you want from me, fair lady?' asked the selkie man.
'I have made a bad marriage and the bed is a cold, unloving place. I want to feel strong arms around me. I want to be loved and to make love.'
'So, you've come to the selkie folk?'
'Yes, I have.'
'Well, I will come to you and satisfy your needs, but I can only take human form every seventh stream. Meet me here at that time.'

The setting for the story also has an amazing landmark in the Vat of Kirbister, a beautiful natural arch which I thought would provide a wonderful backdrop and would be instantly recognisable to everyone who loved these remote islands. I then decided to include the Northern Lights as well for good measure, as the Orkney Islands are one of the places in the UK where they are most spectacular. However, I found painting them very difficult and although I am happy with the image overall, I would, if the chance were presented, do the sky again.

This is not an uncommon dilemma for artists and illustrators. Complete satisfaction with our work usually eludes us, but it does keep us striving for that sense of achievement and that is no bad thing. Learning never ends and challenging yourself to do what is difficult is essential.

I was delighted that author Tom Muir was pleased with the result:

I knew that The History Press used the same artist to illustrate the covers of their Folk Tales series, but I have to admit that I wasn't expecting someone like Katherine. Right at the beginning she contacted me on Facebook, introduced herself and then showed me a drawing of how she envisaged the cover. I was stunned – such a thoughtful and sensitive piece. I knew the story immediately, but only afterwards realised that Katherine had found an image of a coastal feature in Stronsay (where the story is set) to use as a backdrop. That degree of research and care impressed me. I felt that my opinion actually mattered; Katherine remained in contact with me throughout the process. I was as excited as a bairn on Christmas Eve with every new update of the painting. I watched it grow, flush with colour, soften and emerge as a fully complete piece of art; like a butterfly from a chrysalis. We have remained in touch ever since, and my life has been enriched by her friendship. I also have an original piece of her artwork on my wall, which enriches my home.

Monaghan Folk Tales

BY STEVE LALLY

Before I even set eyes on the manuscript of *Monaghan Folk Tales* I received a message from Steve Lally, the author:

Hi Katherine. I hope all is well with you. Would you believe I have written another book on Folklore. It is *Monaghan Folk Tales* this time. I hope you don't think I am being cheeky, but I was wondering if you could take a look at the introduction when you get the manuscript. It is a piece all about collecting the stories on an old ass and cart and it kind of sums up the whole essence of the book. It would make a lovely image and it would be fantastic to see the old donkey being immortalised by your good self. Anyway, I hope all is good with you and the family and all the best. Steve.

An Irish donkey cart? Seemed like a good start … and when I started to research images on the net I found quite a few captivating photographs from the last century and some gorgeous coloured postcard images to draw from. The dimensions are a little tricky, as the carts and donkeys often seem small compared to the people riding them. At first I drew a male figure in my initial sketch but for some reason he just didn't work, so I erased him and sat looking at the space frustrated for a while before going back to one of my original reference photos for inspiration. At about the same time Steve sent me some photos of his partner, Paula, and wondered if I would consider using her as a model. So the man on the cart became a woman, and a specific one at that.

Although I feel this is a successful piece it lacks an energy that many of my other pieces have, perhaps because it is not inspired by the stories themselves as such, but an idea about the collection of them.

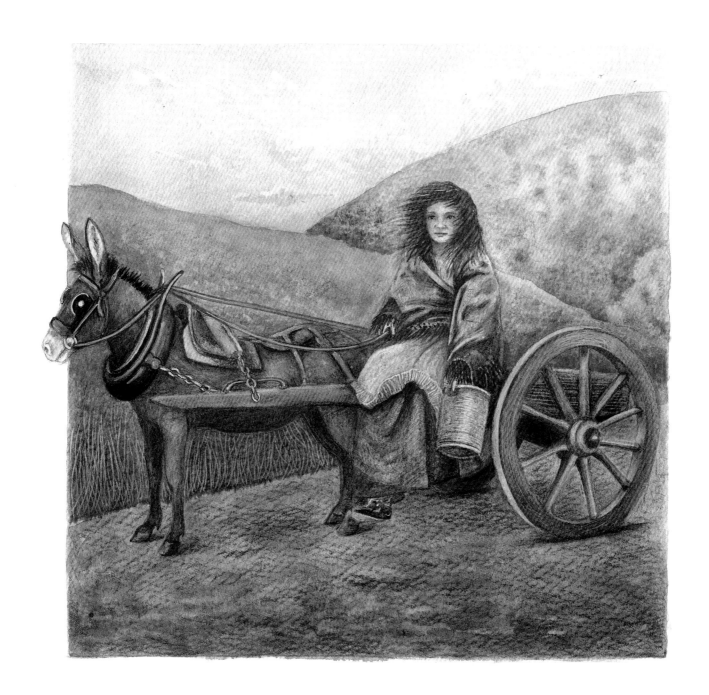

Cumbrian Folk Tales

BY TAFFY THOMAS

The story I chose for the cover of *Cumbrian Folk Tales* was one of the few that made me cry on reading it. It also made me cry a second time when author Taffy Thomas told it, with the painting to refer to, at the preview for my first 'Painting the Tales' show at the Mad Nomad Gallery in Hawick in 2015. I know it is also one of Taffy's favourite tales as he bought the original painting of this cover for his wife Chrissie and it hangs in their home in Cumbria.

'The Hunchback and the Swan' is a beautiful short story of love, friendship and finally finding your place in the circle of life. An outcast from human society finds peace in the company of animals and ultimately becomes one of them.

I chose to illustrate the very end of the story for although there were many images to choose from – the line of animals, the swan plucking at her feathers in the cottage – the moment when the story is so beautifully resolved and the two swans are finally together forever on the lake kept coming back to me.

Living as close to the River Severn as I do, I have often witnessed the loyalty of swans to their mates and their determination to stay on their nests in the face of flood and gale and sometimes even human idiocy. They are undoubtedly rather special creatures, and as water is such a strong feature of Cumbria it was great to be able to depict the lake at Grasmere as well. Water, as I have said elsewhere in this book, is something I love but find quite challenging to depict and I often choose to stylise it in some way, but this painting is a simple, old-fashioned watercolour of a beautiful subject in the Cumbrian landscape. Enjoy.

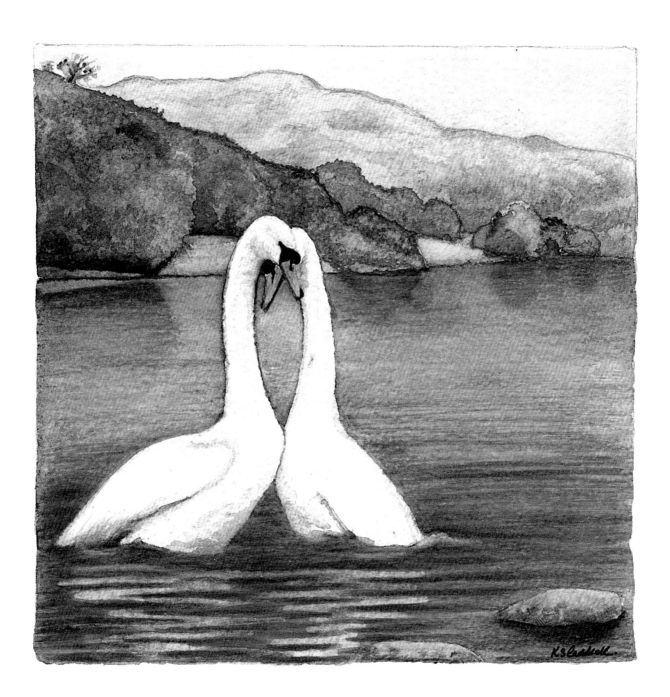

Derry Folk Tales

BY MADELINE MCCULLY

The ever-changing moods of Manannán Mac Lir make him a fascinating character: he is both generous and protective, capricious and cruel, a trickster who can change his shape at will and an inveterate clown. My favourite image is that of him riding the waves with his beloved horse Enbarr of the flowing mane, churning the waves into foam and sending sailors scuttling for safe harbour.

It was this tale that I decided to work on for the cover of *Derry Folk Tales*, but it proved frustratingly elusive for a long time. I tried various ways of depicting Manannán riding through the waves astride Enbarr but none of them conveyed the feeling I was looking for, they just looked like a chap on a horse – there was no magic.

Then I re-read the tale and was struck by the following passage:

When he took the notion to catch a glimpse of his throne on the top of Barrule on the Isle of Man, the other part of his Kingdom, sure all he had to do was fill his lungs and blow and then he'd ride the towering waves. No wonder the locals along the Lough would shake their heads and mutter, 'Manannán is angry today.' Sure maybe he wasn't angry, just homesick, for as I said before, nobody likes to be stuck in the one place all the time and he probably missed his other wee island in the middle of the Irish Sea.

This gave me the idea that perhaps he should be more a part of the sea than riding on it, this shapeshifting magician of the sea.

This proved to be the answer, and in the illustration Manannán's face emerges from the waves behind the galloping horse while a seagull swooping out of the frame adds to the sense of movement.

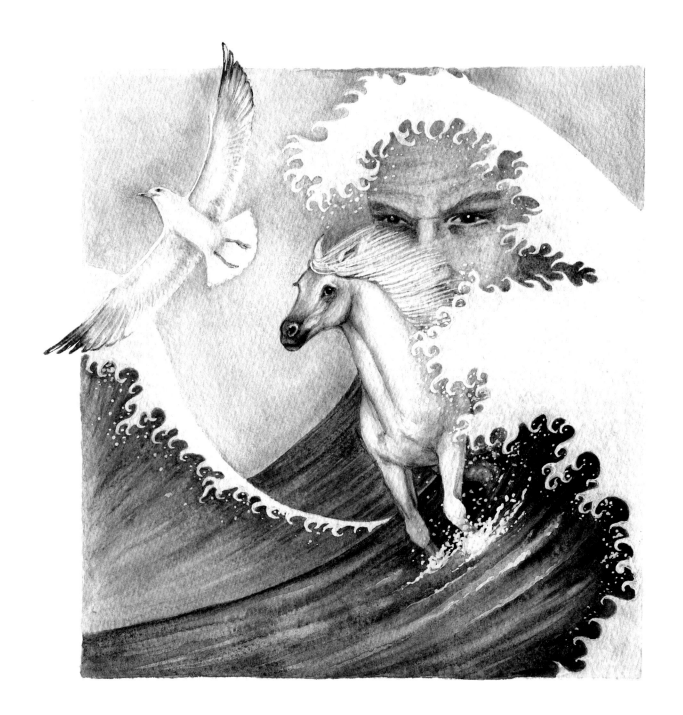

Oxfordshire Folk Tales

BY KEVAN MANWARING

I had always led a simple life, in harmony with the land, harming no one – indeed folk would often come to me with their ailments and woes, just as often for a listening ear as a charm or potion.

So begins the story of Nan, narrated inside the heads of two terrified boys confronted by a white hare that has been shadowing them as they hunted rabbits by the full moon.

I love hares, they are somehow otherworldly even though they are undoubtedly of this world; they seem to be one of the creatures that moves effortlessly between our world and the magical realm, and people all over the world tell stories about them.

The hare has a long association with the moon and with women, almost always referred to in feminine terms in stories, appearing as a goddess or the companion of a goddess, as a messenger, as a fertility symbol and as a trickster.

Hares are also associated with Easter, with the elixir of life, with the last corn standing at harvest-time, and with shapeshifting and witchcraft.

This story combines the hare as moon-soaked messenger and shapeshifter; she relates a sad story we know all too well of a woman persecuted and murdered and the accusation of witchcraft. The two boys, who up until that point had been teasing each other with stories of Long Compton's witches, are faced with a real story of one old woman punished out of spite and ignorance for sins she never committed.

Here then is Nan, sitting on the wall and knowing so many things she can only impart to those ready to hear and willing to listen. Perhaps she will be attending the Hare's Parliament. I know Kevan would like to think so.

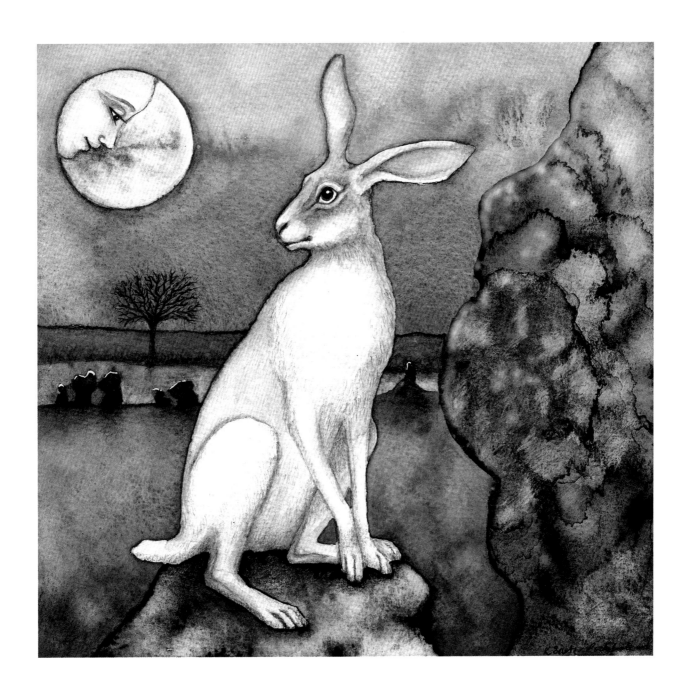

Surrey Folk Tales

BY JANET DOWLING

The story of 'Mathew Trigg and the Pharisees' has a classical 'don't mess with the fairy folk or you will be sorry' theme but with a message about community, old age, sorrow and understanding woven through it, giving it wonderful heart and soul. The image of the elderly man rescued from his fairy tormentors by the intervention of the children of the village and a wise woman is made more poignant by the use of a similarly elderly farm horse, given the chance to experience again the joy of youth and the power of flight.

I wanted to paint old Dobbin taking flight on his mission to rescue Mathew and show him not as a beautiful Pegasus, but as a gentle old horse suddenly gifted with an ability he could never have dreamed of. There is a glint in his eye and for a moment I wondered if he would indeed come straight back as instructed or take himself off for further adventures.

This was also one of the illustrations that refused to be constrained by the boundaries of format: this seems to happen sometimes, an otherwise well-behaved drawing will suddenly up and breach the edges of the frame and won't be put back in for anything.

Dobbin himself forms a window through which we can see the church of St Peter's, which he collides with harmlessly (for him and Mathew anyway) on his all-too-direct route home. The spire at this point is not bent, of course, as he is only setting out on his journey.

Horses are one of the few things I can draw without any kind of visual reference, as I spent so many hours in the fields around my local riding school drawing them from life when I was young and I accumulated a clear visual memory of the proportions, muscles and movement of one of my favourite subjects during that time.

Author Janet Dowling had this to say:

I was so pleased that Katherine had chosen to illustrate Dobbin from Mathew Trigg's story. I almost cried as I saw the pictures posted on Facebook as Dobbin emerged, coming out of the page edge but encircled around St Peter's Church in Ash. After all, the whole story exists just to give an origin story for the broken spire, and the illustration captured it beautifully!

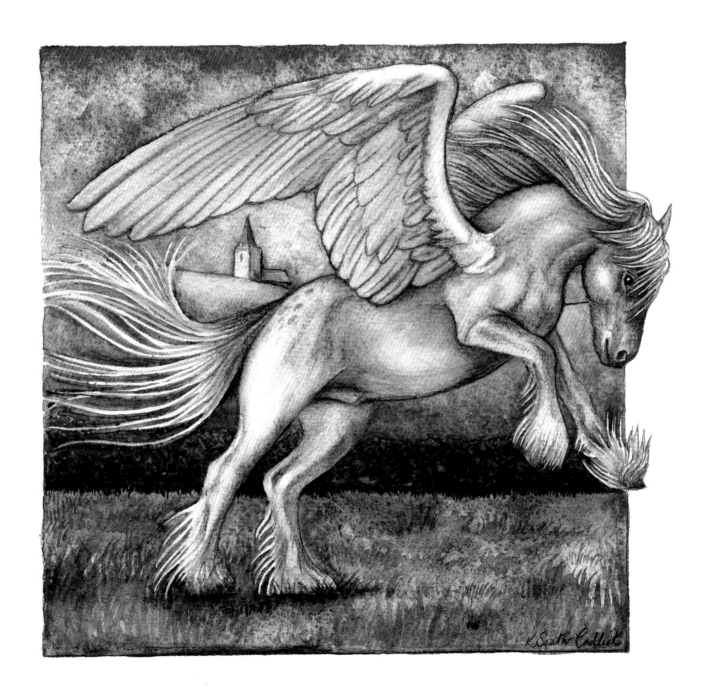

Clare Folk Tales

BY RUTH MARSHALL

The chance to depict a mermaid came to me with the manuscript for *Clare Folk Tales* – one who is taken in and treated gently by the people of the western coast and promises to send them three cows, one black, one red and one white, so that they shall never want for sustenance. She eventually becomes homesick for her ocean home and asks to be returned to the sea, but she keeps her promise and the cows duly arrive.

She sits in the pinkish dawn light, gazing out to sea, wistful for the deep enclosing waters she has left. Like the selkies of so many of my favourite Scottish stories, she can never belong to the land, however long she inhabits it.

Here is the response from author Ruth Marshall to the cover image I chose:

I struggled with this: at first it didn't feel representative of the book's content to me, but still I loved the image.

I loved the colours of that pinky-purple dawn sky. I loved the long flowing black hair streaked with silver. There was a gentleness and feminine wisdom in her gaze. But I wondered, wouldn't it be better to have Co. Clare's famous wise woman, Biddy Early, on the cover? But then, I'd tried several drawings of Biddy myself, and abandoned them, feeling that Biddy didn't want an image of herself in the book. Maybe Katherine realised this too?

So where did this mermaid come from?

Then I realised this must be the mermaid who brought the three cows to Ireland: the Bo Dubh, Bo Derg and Bo Finn (the black cow, red cow and white cow). Such a great gift to the people.

In the story she is gentle and beautiful and wise. She is much loved by the people who quickly take her into their hearts when she washes up on their shore. She is also generous and truthful: she keeps her promise and does what she says she will do, sending the three cows at Bealtaine's sunrise.

She is not constrained within the picture frame: her hair and her tail fin extend beyond the boundary. She is generous, honest and free. She cannot be contained.

I was pleased that Ruth felt able to say she wasn't sure at first; the books in this series are so personal to the storytellers who write them that I have a great responsibility to respect the material when I choose my images. But I also have a responsibility to produce an image that will catch the eye of the book buyer and some of the greatest stories do not translate into good cover images, so it is a delicate balancing act at times.

Interestingly, my first choice had been Biddy Early too, but I could not find an image that I was happy with in my head for the cover, so maybe Biddy really did get her own way …?

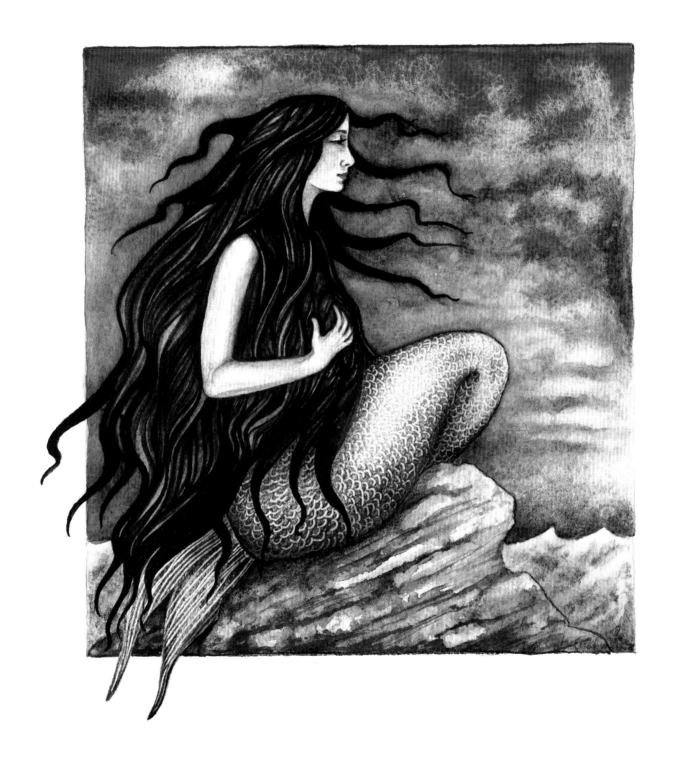

Gloucestershire Folk Tales

BY ANTHONY NANSON

The Buckstone featured in this illustration is a massive conglomerate boulder which used to balance on a boss of bedrock, meaning it would rock back and forth if pushed – before a party of drunken Victorian acrobats permanently dislodged it. In ancient times it was used as an oracle by druids, who made predictions based on the way it rocked when questioned.

When the kings of Britain heard that the Romans had designs on this island they came with their druids from all corners of the country to this place to discuss what might be done to repel this invasion.

At sunset, the druids asked the rocking stone what should be done and its answer came that a blood sacrifice must be made of the first warm-blooded creature they set eyes on when they returned at dawn:

As so often happens in story, it is not an animal that they are greeted by when they return. It was Gwladys, the teenage daughter of King Gwythr of the Catuvellauni. The druids knew that this could not make a difference, the prophecy must be honoured, and they gathered around her with their sharpened sickles.

Gwladys is saved from sacrifice at the eleventh hour when a roebuck appears from nowhere and throws itself into the arms of the waiting druids in a scene reminiscent of the story of Abraham and Isaac. Interestingly, although Gwladys goes on to undertake druidic training partly inspired by this experience, she eventually converts to Christianity, becoming the first Briton to embrace the faith.

Author Anthony Nanson had this to say:

Other Folk Tales authors will have experienced the same suspense about 'Which one will she choose?' I had no expectation of any particular story being a likely frontrunner, but I was surprised by Katherine's choice. 'The Buckstone and the Britannic Palace' is by far the longest, most complex story in the book. It concertinas into a single narrative a number of Gloucestershire legends relating to the Roman invasion and the beginnings of Christianity in Britain – of which the key figure is Claudia Rufina, supposedly the first British Christian, whom I refer to by her Welsh name of Gwladys. Katherine illustrated the opening episode, in which Gwladys is saved from being sacrificed at the Buckstone, in the Forest of Dean, by the timely appearance of a roebuck. I had assumed the Buckstone got its name from its history of being a rocking stone – 'bucking' this way and that in response to the druids' auguries – but Katherine's painting fascinatingly reveals the shape of a roebuck in the pattern of erosion of this rock, matching that of the actual roebuck leaping past. What makes the picture really striking, though, is the portrait of Gwladys as flame-haired Celtic princess gazing straight back at you with big blue eyes. Her prominence there seems fitting as representative of the many strong female protagonists I discovered in Gloucestershire's legendarium and whose stories I have included in this book.

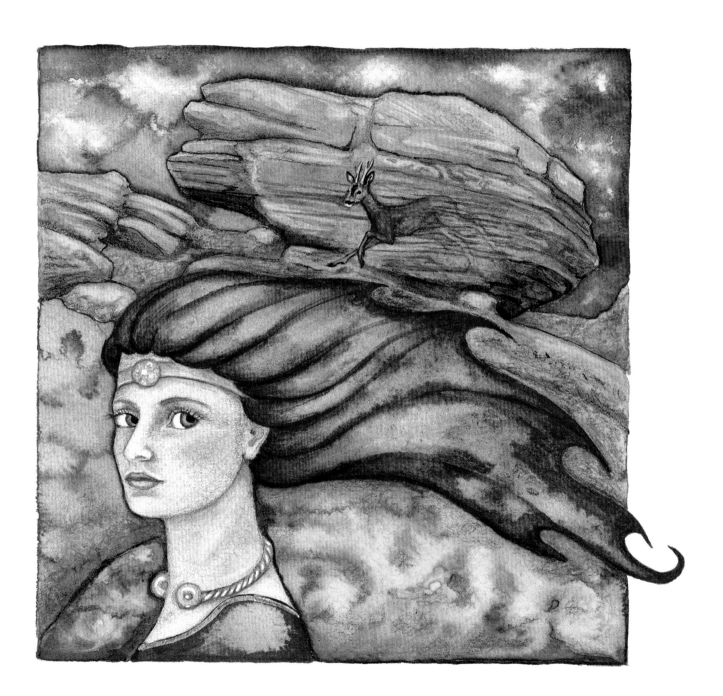

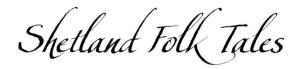

Shetland Folk Tales

BY LAWRENCE TULLOCH

When I receive a new Folks Tales manuscript, I always hope for stories that are unique and particular to the area which will allow me to produce a cover image that reflects something special about it that is intriguing to the reader.

With *Shetland Folk Tales* by Lawrence Tulloch I had a good choice of tales that were peculiar to the islands, as often happens with the more isolated parts of the UK. This is a wonderful but also a tricky thing, as being spoilt for choice can sometimes lead me to inertia while I try to decide which direction to take. So I started to google Shetland images to get more of a flavour of the islands and in the hope that something would lead me in a particular direction, and indeed I found a photograph taken in the 1920s of a group of children wearing curious costumes of straw.

These children, I discovered, were dressed as 'Skeklers'. Skekling is an old Shetland folk tradition whereby Skeklers would go round the houses in their distinctive straw costumes at Hallamas (New Year), and turn up at weddings in small groups performing fiddle music in return for food and drink. It is believed that this fascinating custom had all but died out by 1900 and the children I had seen in the old photograph were actually a recreation of the tradition for the Up Helly Aa festival.

I remembered making notes that said 'straw costume??' and went back to find the story that it featured in – 'The Hallamas Mareel'. Now I had an arresting image and a good story to attach it to, and having also found some images of the landscape in the story I was all set.

There were a few challenges along the way, mostly to do with how the light would work as I needed the figures to have detail when they should have been in silhouette with the moonlight behind them. But that is why I illustrate – so that I can play around with these realities. The child's wistful face came from a book of vintage photos I have called 'anonymous' and which I often turn to for inspiration. You will have to read the story to discover why the other figure is wearing a cloak covered in herring skins …

This is my only cover (as far as I know) to appear on TV: when *Shetland Folk Tales* was given as a gift in an episode of the BBC detective series *Shetland* I received a flurry of messages for which I was grateful, as I had no idea since I don't have a television!

Donegal Folk Tales

BY JOE BRENNAN

'The Bee, the Harp, the Mouse and the Bum-Clock' – I loved this story from *Donegal Folk Tales*; the animals danced right off the page and into my head. The discovery that Bum-Clock is the Irish name for a cockroach just made me love him more:

Now when he entered the town he spied a great crowd gathered in a ring in the street. Not one to let his curiosity to lose out Jack made his way into the middle of the crowd. His eyes widened to saucers when he saw a man in the middle with a wee wee harp, a bee, a mouse and a bum-clock in his hands. When the man put them all on the ground and whistled, the bee began to play the harp, and the mouse and the bum-clock stood up on their hind legs, took hold of each other and began to waltz with great elegance.

It was difficult to create a cover image of them at first, though, a straight depiction of a scene from the story could be too twee and while that may be fine for a children's title, these are stories for adults in the main. In the end I had the idea that perhaps the mouse and the bum-clock could be emerging from the harp, as though they came into existence as it started to play. Many, many hours of layering with Inktense inks followed, resulting in an image that I was very happy with but also with a quiet promise to myself that I would not tackle another item made of wood for a little while.

Scottish Borders Folk Tales

BY JAMES SPENCE

All around and everywhere there was a magic stillness. The fish snoozled in the stream, water birds snoozled in the reeds, all the critters of the fields snoozled in the shade. All was still and all snoozled forby the hares at the playing of the pipes. All day long the hares danced. It was only when the laddie saw the sun poised over the trees in the west that he stopped his playing. Only then did the hares stop their dancing. Only then did all the other creatures stir from their glamour.

This passage from the story of the boy who looked after hares in *Scottish Borders Folk Tales* was so beautiful that I formed a picture in my head immediately and started to work on depicting the young man with his entourage of dancing hares.

It wasn't going to be easy, though, this one. I wanted enough distance in the image to show the hares dancing around the figure of the piper but also wanted it to feel intimate at the same time. There was also the question of scale and perspective to grapple with. And, to top it all, I needed to make hares dance …

In the end I concentrated on getting my hares right and didn't add the piper until much later, thinking that it would be easier to place him among them than to add them around him. This was partially true, although I had a few false starts trying to do it. My son Tam was again drafted in as a (more or less) willing model, as I wanted a particular pose and drawing someone holding an instrument of any sort is always a bit tricky.

The colours in this illustration are very strong. I am not entirely sure why they grew that way except that there is a certain time of day when everything becomes brighter and more defined as evening approaches and the shadows lengthen.

Cambridgeshire Folk Tales

BY MAUREEN JAMES

I had come across the story of 'The Fearless Girl' before in various guises, but particularly liked this version retold by Maureen James in *Cambridgeshire Folk Tales*. Folk tales of women and girls being strong and assertive and not getting punished for it in some way can be few and far between, so I am always attracted to them. In this story the indomitable Mary is challenged by friends of her father to perform a task they are sure will make her fearful, after her father proclaims that she is afraid of nothing.

Mary, true to her fearless nature and with an air of practicality, goes down to the bonehouse and brings back a skull, despite all efforts to scare her. I love her matter-of-factness as she says, when asked if she has done it, 'Of course I have, I am fearless.'

The same is not true of her potential tormentors and one of them expires of fright when accidentally left behind and locked in the crypt.

This is the only time I have ever used anyone famous as a model for an illustration, but I was watching the HBO series *Game of Thrones* at the time and Maisie Williams as Arya Stark epitomised for me the sort of young, dauntless and determined female character I would have so loved to see on screen when I was young and seeking strong role models, so I decided she would be perfect for the face of the fearless girl. Not everyone will know or recognise her but that is part of the fun in this case.

Roscommon Folk Tales

BY PAT WATSON

The stirring story of the fair, brave and headstrong Una Bhan, who dies for love after her father refuses to let her marry the man she has chosen, is positively Shakespearian in theme and I loved the language of the story, the pathos and the drama in the vision of those divided lovers reunited in death. The image speaks almost of rapture, and I have an affection for hopeless romance and star-crossed lovers that is evident.

It is said that Lough Cé sprang from the grave of the Druid Cé of the God Nuada, who died from battle wounds just as he reached the beautiful plain of flowers he journeyed longingly towards. He was buried where he fell and the resulting lake bears his name forever. It seems a perfect setting for a tale of doomed love:

Una Bhan paddled out in a little boat to the rock on Lough Cé. She sank the little boat, climbed the rock to where her ancestors first fell in love, returned that love to the God of Water and paid their debts to the Gods who created Lough Cé by dying for love. She was buried there and like the beggar woman said she will be remembered forever, but not in the way her father expected.

When Tómas Láidir finally returned and found out what happened he cursed himself for not returning sooner, he cursed her father for slighting him so and killing the lovely Una Bhan. He swam out to the rock, climbed up to her grave and laid beside it through the day and night in his wet clothes. The next morning he had great difficulty breathing and before the sun appeared out of the morning mists, he was dead.

This was another chance to paint an interesting sky, which, as you may have noticed by now, is a thing I am rather fond of.

Bedfordshire Folk Tales

BY JEN FOLEY

The story behind the cover for *Bedfordshire Folk Tales* is one of revenge, rescue and atonement. There are three brothers, all highwaymen: one who is cruel and dominating and abandons his sister to an abusive relationship, one who is young and loves his sister and whose resentment eventually overflows with tragic consequences, and the third, possibly one of the most interesting characters I have come across, who sacrifices himself for the sins of his brothers in almost biblical fashion so that his younger brother may live and support his sister.

I don't often tackle men with guns (actually, never until this point) but this wasn't the only story of highwaymen in the book so I felt they were something of a theme here. I tried various ways of depicting him but they all looked a little tame, or somehow uninvolved in their own illustration. So I bit the bullet (so to speak) and had him aim his pistol out of the picture directly at us: he's now involved and, whether we like it or not, so are we.

This is another illustration largely executed in Inktense, which I find so useful for building atmospheric layers and creating grungy effects. The spattering of dirt, which I imagined time spent on English tracks and roads would make inevitable, is created by shaving the Inktense sticks onto the dampened paper with a knife. It is an uncertain but rather satisfying process when it works; when it doesn't, there is the slightly panicked application of tissue paper and quiet swearing.

Western Isles Folk Tales

BY IAN STEPHEN

The author of *Western Isles Folk Tales*, Ian Stephen, was keen that there should be a maritime theme to the cover and very kindly sent me information on traditional sailing vessels, which led to much satisfying and later head-scratching online research as I sketched various boats and tried to get my head around things like sails and rigging, having not drawn a sailing boat before.

Then I needed to find the right story and 'The Two Ravens' is another story involving shapeshifting. The tale of two female members of a family attempting to prevent the marriage of a third was marvellously evocative and featured a birlinn, one of the boats I had made sketches of during my research. In the story, two high-ranking maidservants transform into ravens and track Alisdair's voyage across the Little Minch, bringing a string of bad luck to the voyage until he spots them and injures one. All is eventually well and no one ends up the worse for the experience after he chooses to forgive rather than punish and smooth ruffled feathers rather than cause a family feud. Wise man.

The problem I had was depicting the ravens' significance whilst also including the entire birlinn. In the end, I opted for having the ravens further forward in the picture and hoping that people would not think 'Blimey! Ravens are enormous in Scotland!' I think it worked … certainly the author was happy, as I received this email from Ian a little later: 'Christine and myself both think the cover illustration is spot-on – works within series but hones in on a unique tale – and the birlinn drawing is accurate for the period – great.'

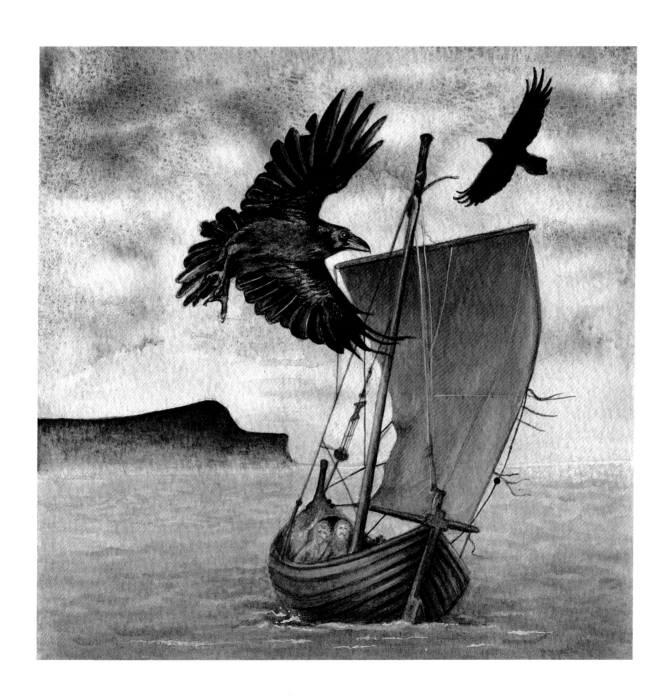

South Yorkshire Folk Tales

BY SIMON HEYWOOD AND DAMIEN BARKER

I have known Simon Heywood, co-author of *South Yorkshire Folk Tales*, for many years, and am an admirer of his work, so this was a title I was looking forward to working on very much and knew we would be in close contact throughout.

I often ask authors if they have any ideas or preferences concerning the cover, and asked Simon the same question. 'Just read it through and see what jumps out,' he replied somewhat cryptically.

'The Cat and Man' story is one of the most visceral and emotional pieces I have read in the whole Folk Tales series. Whether or not the real Percy Cresacre (who was not, incidentally, a crusader, although his grandfather was) ever fought this battle himself, or if it is an adaptation of a number of tales and myths about the conflict between the powers of man and nature, does not matter at all, it is an incredibly moving story of courage, tenacity and humility in the face of death.

I knew I had to tackle it.

I sent my first sketch to Simon for feedback and waited … he was very pleased I had chosen the story: it was a favourite of his and of his wife, Shonaleigh.

He loved the composition but tentatively suggested the cat needed to be a bit scarier-looking than the Scottish wildcat I had chosen. A lynx perhaps? They certainly once roamed the British countryside. The lynx turned out to be a perfect fit and I set about trying to depict two beings that have been fighting each other for an entire night and knew that their battle could only end one way.

I built the layers carefully up with Inktense, both painted and splattered on with a knife, and started to wonder how much blood it would be possible to show; the balance had to be right, but there had to be blood there. I sent Simon the latest version and asked, 'A bit more? What do you think?' And he said, 'Go for it!' Mixing exactly the right colour for blood is always a little tricky but I was eventually happy with what I achieved, the last few smears were applied with my fingertips and flicked on with a brush.

It was a piece I enjoyed so much I was almost disappointed when I finished it.

The original painting now hangs in Simon and Shonaleigh's home.

Antrim Folk Tales

BY BILLY TEARE AND KATHLEEN O'SULLIVAN

The beautiful and tragic story of how Fionn MaCumhaill finds and then loses the love of his life is one of my favourites about this iconic Irish warrior:

> He had met her when out hunting with his men. They had pursued a deer over many miles, until they were back close to their own fort. Fionn was at the head of them all, with his hounds Bran and Sceolan, and was amazed to see that when the dogs caught up with the deer, instead of cornering or savaging the animal, they ran around her, whimpering with excitement, their tails wagging. The deer turned to Fionn and that was when he first saw those beautiful eyes. He was captivated by the deer and would not let anyone harm her. Instead, she was taken into the fort and stabled with the horses …

That night the beautiful Sadb comes to him as a woman and explains how he has broken the dark enchantment that had made her lead her life as a deer. They marry and are happy and deeply in love until the dark druid tricks the pregnant Sadb out of the fort and, transforming her back into a deer, spirits her away. Fionn never sees her again, although he is in time reunited with his son, Oisin, meaning 'little deer'.

Shapeshifting is a favourite theme of mine, it seems to be a universal fascination in folk tales and there are many references to it in Irish mythology. Fionn's two famous hounds, Bran and Sceolan, are a curious example. They were conceived as human children but when their mother Tuirrean (Fionn's aunt) was turned into a wolfhound while she was carrying them in her womb, they also transformed and were born into the world as puppies, becoming Fionn's constant and loyal companions.

In the illustration Sadb peers through the woodland, her human face above her, her eyes looking for the warrior and the love she will find for a short but beautiful interval before ending her days under the curse of the druid once again.

Wiltshire Folk Tales

BY KIRSTY HARTSIOTIS

I seldom get asked right from the start to include a certain feature in the illustration, but *Wiltshire Folk Tales* came with a note asking that the cover feature Stonehenge. It certainly is an iconic part of the landscape and I could see why the author was keen to include it. Then I read 'The Raising of the Giants Dance', which was a story I had never come across before where Uther Pendragon and Ambrosius enlist the help of Merlin to purloin the entire monument from Ireland and rebuild it magically on Salisbury Plain. The imagery of Merlin with the stones swirling around him was a rather wonderful one but I realised they would actually have to look like Stonehenge on the cover, or no one would recognise them.

The idea of the stones themselves having life and agency is also strong in the stories and I wanted to portray them almost as living beings, filled with the memory of all they had seen and experienced during their long vigil on Salisbury Plain, so I carved signs and wonders into their surface and hoped they would be understanding of my artistic licence. I was happy with the stones but if I had the chance again, I would render the sky a little differently; on reflection, I think that watercolours and Inktense would have been a stronger colour choice.

Author Kirsty Hartsiotis said the following:

Okay, I was a newbie when it came to books and illustrators when doing this book! At the time, I didn't know Katherine, or how she worked, so I made a request that the cover should have Stonehenge on it, thinking marketing etc. Katherine rose to the challenge – I love the image she created of a Stonehenge living with figures and sigils that captures my love of megaliths (there might be a few in the book!) and their mystique as numinous places, no matter how many people tromp by them, unseeing. But – sorry, Katherine for forcing your hand! I do cringe a little whenever I think of it.

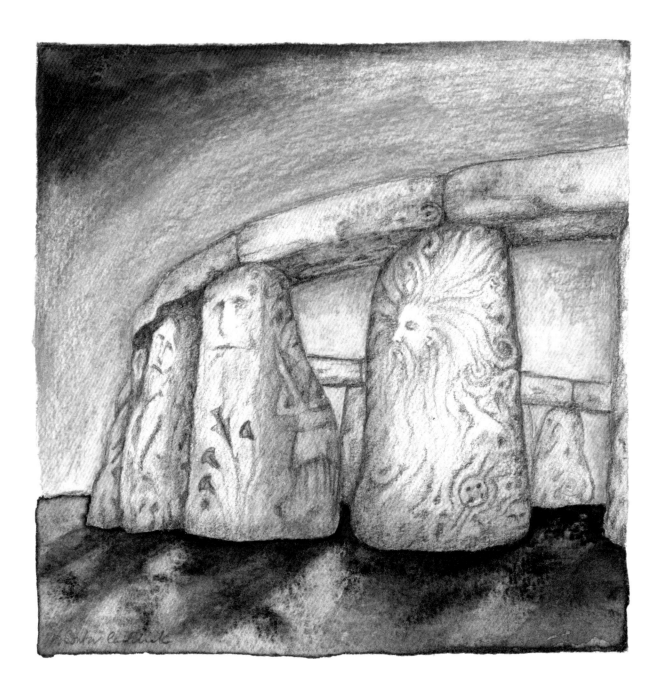

Leitrim Folk Tales

BY SUSIE MINTO

There are several famous characters called Macha in Irish mythology; it is likely that they all represent aspects of the one sovereignty goddess, who was one of the three sisters known as the Morrigna. She is associated primarily with the land, fertility, kingship, war and horses. It was also said that Macha was called Grian Banchure, the 'Sun of Womanfolk'.

Macha Mong Ruad ('red hair'), daughter of Áed Rúad ('red fire' or 'fire lord') was, according to medieval legend and historical tradition, the only queen in the List of High Kings of Ireland. Her father Áed rotated the kingship with his cousins Díthorba and Cimbáeth seven years at a time. Áed died after his third stint as king and when his turn came round again, Macha claimed the kingship. Díthorba and Cimbáeth refused to allow a woman to take the throne, and a battle ensued. Macha won, and Díthorba was killed. She won a second battle against Díthorba's sons, who fled into the wilderness of Connacht. She married Cimbáeth, with whom she shared the kingship. Macha pursued Díthorba's sons alone, disguised as a leper, and overcame each of them in turn when they tried to have sex with her, tied them up, and carried the three of them bodily to Ulster. The Ulstermen wanted to have them killed, but Macha instead enslaved them and forced them to build Emain Macha (Navan Fort near Armagh), to be the capital of the Ulaid, marking out its boundaries with her brooch (explaining the name Emain Macha as eó-muin Macha or 'Macha's neck-brooch). Macha ruled together with Cimbaeth, then alone for a further fourteen years after his death.

This is the version of Macha I chose, and I chose to portray her connection with horses too. I loved her for her resolution, her courage and her intelligence, qualities that I also associate with horses to a large degree. Of course, she also famously has red hair, something for which I have a great affection. I hope I have done justice to her here.

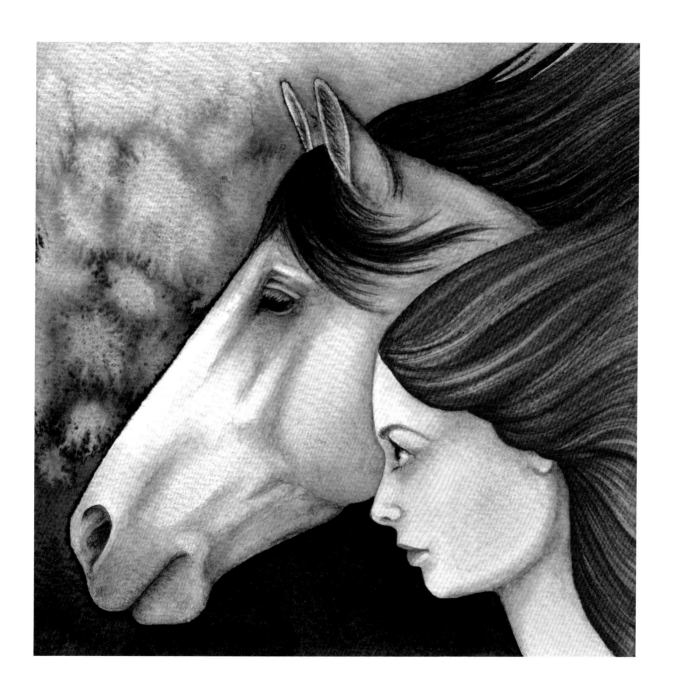

Staffordshire Folk Tales

BY THE JOURNEY MAN

For the cover of *Staffordshire Folk Tales*, I chose to reference a famous landmark and a well-known Staffordshire story that has been used as the basis for a 'dark ride experience' at Alton Towers theme park.

The uniting factor between them is that one is definitely not what it seems at first glance, and the other may well not be either.

Mow Cop is an impressive hill with an ancient-looking ruin at its summit whose arches, which almost frame the sky, certainly spark the imagination. In fact, there are many whispers associated with this hill, but few to do with those supposedly ruined remains. One of my favourite authors, Alan Garner, also used it in one of his novels, *Red Shift*.

The castle is in fact a folly commissioned by Randal Wilbraham of Rode Hall. His hope was to set up a crumbling fortress which would provide a romantic picnic spot.

In the foreground of the illustration is a section of the famous Chained Oak in the village of Alton. This tree is supposedly wreathed in chains to prevent the branches from falling and fulfilling a curse laid upon the family of the Earl of Shrewsbury by an old beggar woman he refused to aid on his way home one stormy night. The story goes that if a branch falls, a member of his family will die. (You would think these noblemen would know better than to ignore the entreaties of old beggar women by now ... nothing good ever comes of it!)

But as far as anyone can tell it is unlikely that anyone has actually died as a direct result of the curse, and the oak may just be chained for its own sake, as many elderly oaks are when they need to be afforded support in various ways. But it is a good story, and that is what matters.

When I thought I had finished this illustration and came back after a break for a last look, I realised it was missing something – it looked rather static and a little unbalanced. A group of crows flew up and saved me, as they sometimes do, and it was complete.

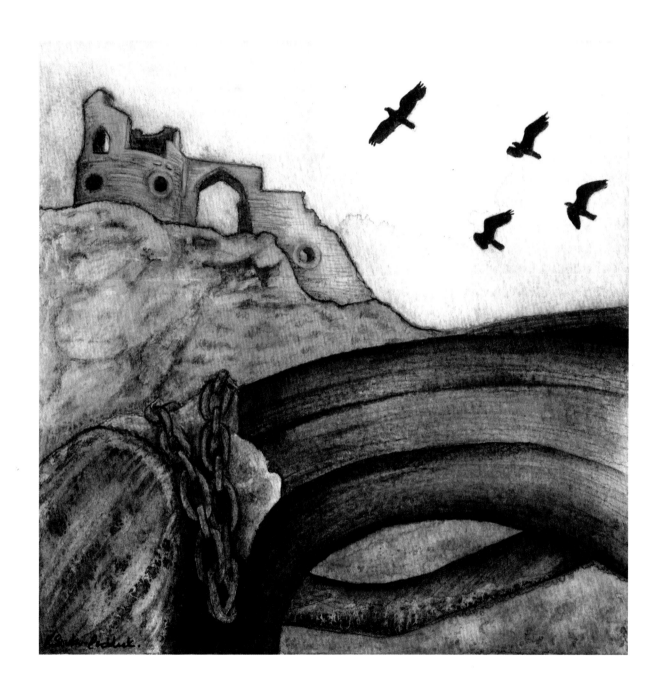

Highland Folk Tales

BY BOB PEGG

He never did kill another seal but whenever the moon was full he took out a silver whistle and played a tune, and after a while a great seal would slip its skin on the beach and all night long she and the seal killer would dance on the beach and when the sun rose the queen of the selkies slips back into her skin and away into the waves.

This story of a hunter redeemed by his contact with the selkie folk really spoke to me; it is only when we learn to empathise with those we have always regarded as 'other' that we can begin to understand them and feel compassion.

The communing under the full moon thereafter of these two beings, so utterly different but united by music and mutual understanding, was such a beautiful image.

I also wanted to find a way to say something about the incredible landscape of the Highlands mentioned in so many of the tales in the book, which was going to be difficult by the moonlight mentioned in the story, so I put my reformed whistle-playing hunter into the sky as a pattern of Celtic knotwork and his seal companion waits for nightfall just offshore. She is a grey seal, the larger of the two species found on the Scottish coast and one I have encountered myself several times, as they are often a little bolder than the diminutive common seal.

The landscape feature is the amazingly beautiful Duncansby Head, the most northerly feature of the Highlands, further north even than John O'Groats, and it provides a spectacular backdrop to the story.

Author Bob Pegg got in touch: 'Just to say thanks for the lovely cover for *Highland Folk Tales*: you picked up on "The Seal Killer", one of my favourite stories.'

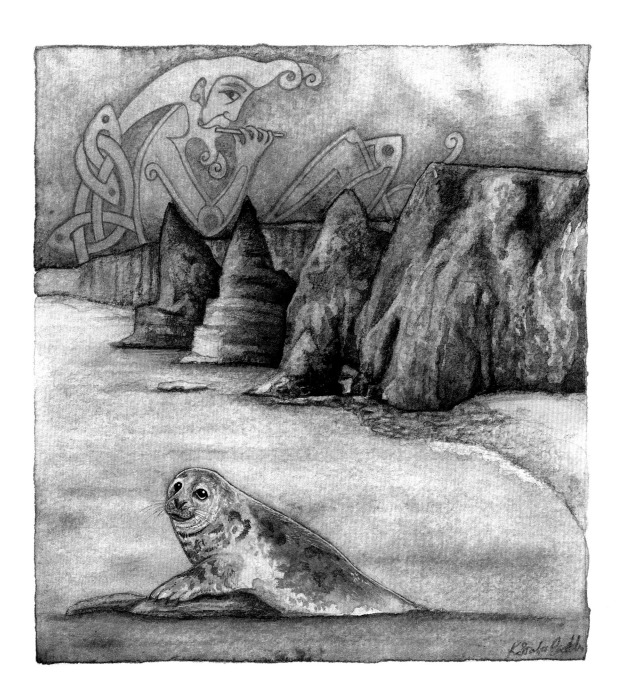

Lancashire Folk Tales

BY JENNIE BAILEY AND DAVID ENGLAND

The beautiful passage below about the wild lady Sybil, who wanted to be at one with the natural world and frequently escaped her mundane existence to celebrate it, was my inspiration for this cover. She symbolises so much to me about my own feelings about being out alone in the wild places of the earth, feeling nature's heartbeat in my bones. I think the image says everything here and needs no explanation:

Whenever the moon was full and high, she lay in the bracken by Eagle's Crag and gazed upon her, until her senses reeled and she became entranced. In her trance, she became rabbit and stoat. She became hare and harrier. She became lark and hawk, pigeon, partridge and plover. She became gorse and heather, couch grass and fern, tormentil and wild thyme. But, her greatest joy, on such a night as this, was to become a milk white doe, a pale streak racing across the high, wide moor, or standing upon Eagle's Crag, framed against the moon and calling to her. Thus she learnt the secret lore and language of the earth.

Lord William fell in love with Sybil and sought to protect her from herself, as men often see themselves as doing. He did have a genuine fear to contend with though, as murmurings of witchcraft often attached themselves to women like her and could prove fatal in such superstitious times. With the help of another wise woman he captures Sybil in her doe form and takes her home to live with him, which she seems to do happily, but she never really gives up her old ways …

Each day Lady Sybil walked the high, wide moor collecting herbs, often with animal names. Her family never ailed but she had a potion or poultice to soothe and heal them. And on such a night as this, whenever the moon was full and high, her soul would soar out onto the high, wide moor, where she would lie in the bracken by Eagle's Crag and gaze upon the moon. Entranced, she became the creatures of the moor. Best of all, she became the milk white doe, standing at Eagle's Crag, framed against the moon and calling to her. So, whenever the moon is full and high, if you have the eyes for it, you can see her still.

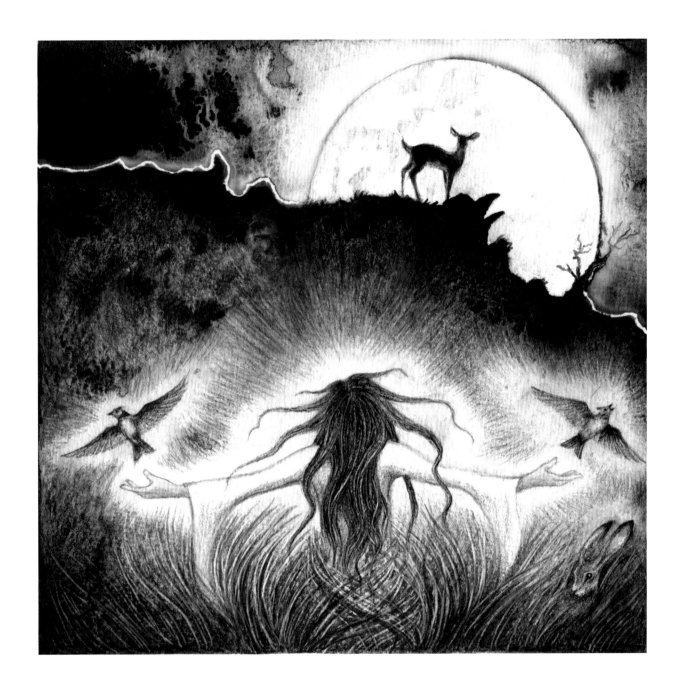

Tipperary Folk Tales

BY AIDEEN MCBRIDE

The story of Darby Milligan, a young piper encouraged to become a great piper by the intervention of one of the 'little men', gave me an opportunity to research the Tuatha Dé Danann, the folk of the other world; or as we now know them, the fairy folk.

> He was playing one day on a stone up on the fields when a little man suddenly appeared to him. He was dressed in a green coat and he had bright red hair. Darby stopped playing.
>
> 'Oh play on,' said the little man.
>
> Darby played on.
>
> 'You are a good player,' said the little man and he took out a new shiny penny. 'Here's a penny for you and there'll be one for you under that stone every time you play here, but mind now, a penny for a tune and don't you ever take the penny without first playing the tune.' Darby took the penny and the little man disappeared. Darby looked at the penny for a while, then he put it in his pocket and played another tune. When he finished he looked down at the stone, there was another shiny new penny, he put it in his pocket and played another tune. He sat there for the evening playing tunes and pocketing pennies. By the time he went back to his bed for the night he was too tired to play for the neighbours.

The fairy folk have a soft spot for musicians, so much so that even after young Darby becomes selfish with his talents and takes to drink and they take everything from him to teach him a lesson, they still give him the chance to regain his former place in society. I also discovered that the Tuatha Dé Danann are not always small and that it is possible that they were once gods and goddesses, as well as representing the positive side of nature and being given to interacting with humans when the right opportunity presents itself. I still hope to meet one, although my Irish whistle playing needs rather a lot of work.

Painting musical instruments is always a challenge, as I know that musicians are intimately acquainted with their tools and I want to represent them accurately. Interestingly, when I posted this illustration online at its nearly finished stage, someone commented, 'Those fingers belong to Davey Spillane do they not?' So not just the pipes, but a famous piper's fingers can be recognised in isolation, because they were indeed the fingers of Davey!

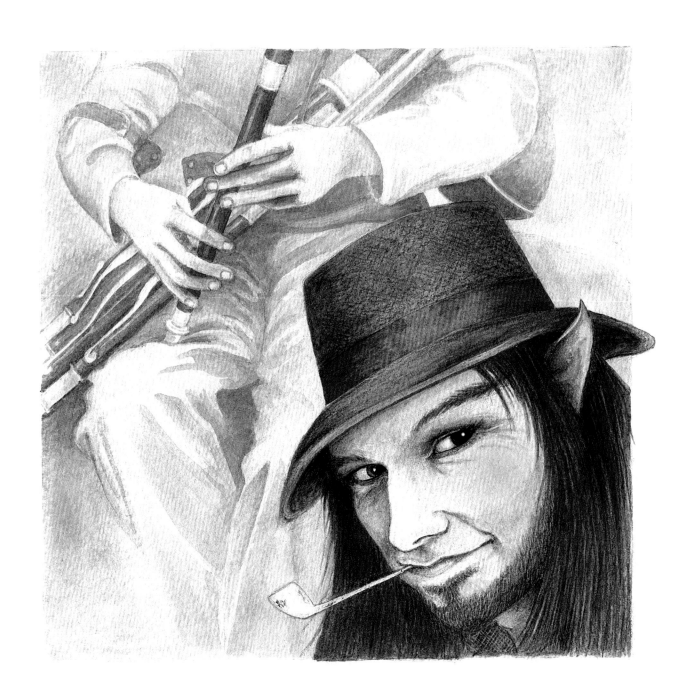

Devonshire Folk Tales

BY MICHAEL DACRE

The idea for the cover of *Devonshire Folk Tales* came not from one story but several about supernatural hounds that roam the county of Devon.

The first was the story of Lady Howard who was said to run, in the shape of a huge black dog, from the gateway of her house at Fitzford to Okehampton Castle, there to pluck a single blade of grass from the castle mound and bear it home in her mouth. Her unfortunate ghost was condemned to perform this penance every night until every blade of grass on the mound was plucked and then the world would end. It was believed that this penance was for her wickedness in life, but having read her story I suspect she was more sinned against than sinner, as was often the truth for women at the time.

Okehampton Castle keep, rising like a sparse set of jagged teeth from the castle mound, seemed a fitting setting for spectral hounds of all sorts and I could also easily imagine the Devil (or Dewer as is he known in Devon) riding through the castle with his fire-eyed whist hounds at his heels. There have been frequent sightings of the ghostly, baying pack in the county over the years.

Then there is the story is of the wicked squire Richard Cabell, who considered himself a great huntsman and had an extremely unpleasant habit of hunting down local maidens and imprisoning them in Hawson Court for his pleasure. Many of the locals believed that he had sold his soul to Dewer and it was said that when he died in 1677 the wild hunt chased him across the moor, one of the great black whist hounds tearing out his throat while Dewer sat astride his black stallion and laughed …

It was this story of the evil squire coming to a bad end on the moor that inspired Conan Doyle to write one of Sherlock Holmes' best known adventures, the chilling and evocative *The Hound of the Baskervilles*.

Rather than portray an actual hound against the backdrop of Okehampton Castle keep, I decided to adapt a favourite gargoyle that I had in my research files; after all, these were not fleshly dogs but creatures of imagination and fearful superstition. I hope you like him.

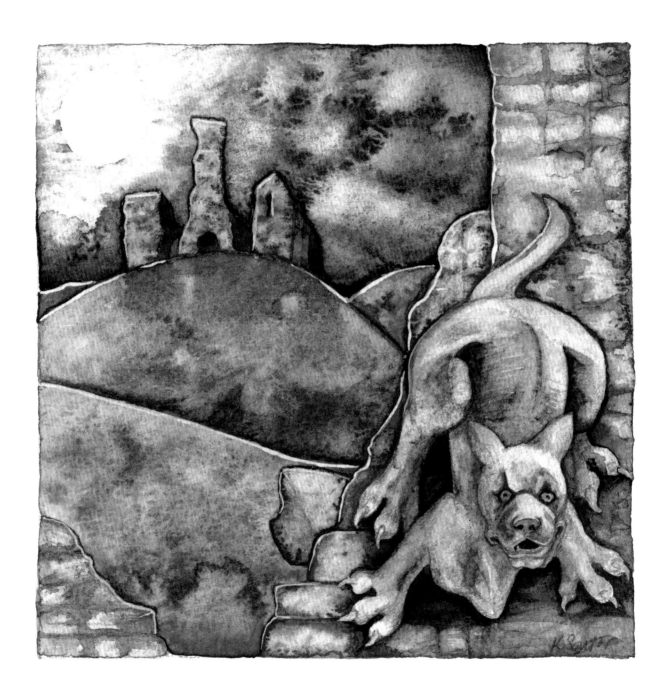

Kildare Folk Tales

BY STEVE LALLY

The pooka or púca (Irish for spirit/ghost) is a much-feared creature in Irish folklore. It is a solitary spirit, often malevolent, occasionally generous, always capricious.

It assumes many shapes and although most often a horse, can appear as a goat, a bull, an ass, a dog or even an eagle. Or, occasionally, a melding of one of these with a human form, for like all spirits it is only half in our world, and half in another we only glimpse in dreams and darkness.

I was drawn to this story because it was a different take on the pooka tale and because I have always been fascinated by the idea of shapeshifting, and here was an opportunity to imagine it … I chose the transformation scene as I wanted to explore what the in-between stage from boy to horse might look like and also to show the surprise at becoming a horse on a horse's face.

Shapeshifting is a recurring theme in story in every culture of the world and has been written about, spoken about and depicted since the dawn of time. The idea that we could become the animals we share our space with, not only to run, fly or swim with the ease that they do but to have the shape of those stronger and swifter than ourselves, must have been a powerful one for our early ancestors and shapeshifting has always been connected with the actions of deities, the denizens of the otherworld, or the exercise of magic.

Shapeshifting also plays with our ideas of what it is to be human and whether our sense of superiority over and separation from the natural world is as thin as gossamer and can be taken from us so easily, plunging us into potentially darker and more sensual places and making us aware of our animal selves. Thus shapeshifting as a punishment could be an equally terrifying concept to many of us.

But perhaps, if we could reconnect more with these wild aspects of ourselves and be less afraid of the beast within us, we would be more respectful of the beasts out there and better able to appreciate wildness more and domestication less.

So is the pooka still out there, lurking in the hills and forests, or should we seek to find it in the nearest mirror …?

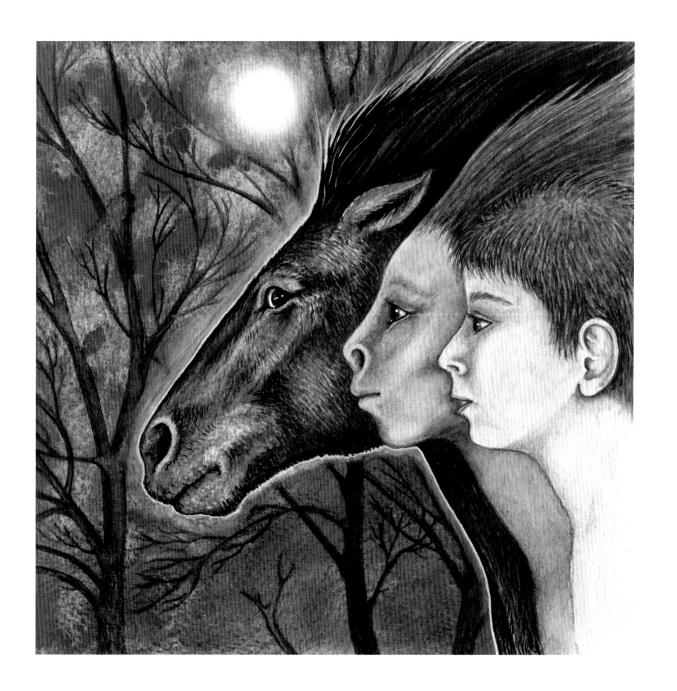

Manx Folk Tales

BY FIONA ANGWIN

The cover of *Manx Folk Tales* features elements of two stories in the text: the tales of the tail of the Manx cat (or rather the lack of tail) and the tale of the Moddey Dhoo, or black dog, of Peel Castle.

The Manx cat is so symbolic of the island that I very much wanted to feature one on the cover, but it needed a context that would make the image work for the series, and when I read the tale of the Moddey Dhoo and began to search for images of Peel Castle I realised I had found my backdrop. It would have been churlish to have made no reference to the famous black dog himself, especially since I had chosen to insert a feline interloper into his territory, so I decided to have his blazing eyes looking over all … probably somewhat disapprovingly.

Now I had the problem of positioning the cat so it was clear that she was tailless and making some reference to the story, which is about Vikings cutting off Manx kittens' tails to use as fashion accessories, which prompts the mothers to start removing them themselves to make them safe from Viking swords and leads to a strange sort of Lamarkian evolution of tailless cats in a generation.

One of the other theories about their evolution is that they are crossbred with rabbits, which gives them their odd stance and slightly out of proportion back legs, but somehow that seems even less likely than the attack of fashion-obsessed Viking warriors!

So here she stands, having been bleached from tabby to white during the painting process when I realised she was blending into her surroundings a bit too much, looking marvellously tail-free and standing in front of a gorgeous Viking helmet I found to stand in for her tormentors.

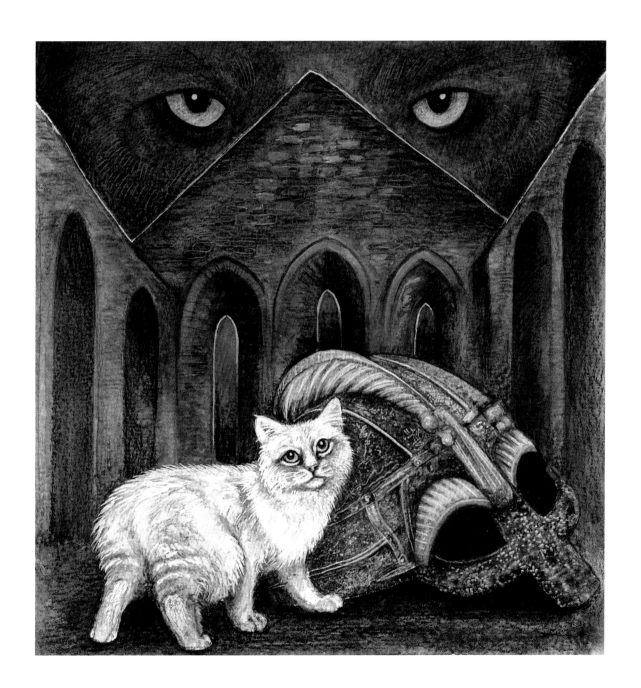

Sligo Folk Tales

BY JOE MCGOWAN

The Bean Sidhe, or Banshee, is still heard in Sligo and other parts of Ireland where the belief persists that she can be heard crying for the souls of those about to die. If you hear her then you know it is not for you she cries, for the dying person will never know the sound. There is some honour in your family being followed by a Banshee, as she only wails for the death of folk with a truly Irish heritage:

> For the high Milesian race alone
> Ever flows the music of her woe!
> For slain heir to bygone throne,
> And for Chief laid low!
> Hark! … Again, methinks, I hear her weeping
> Yonder! is she near me now, as then?
> Or was but the night-wind sweeping
> Down the hollow glen?

The cry of the Banshee is like the sound of the keeners of long ago, local women who gathered to cry or 'keen' at wakes. Lady Gregory described it as 'rising to a high pitch and then falling down again', receding and rising. She is seldom seen, and when she is it is often in the form of a bird or a woman dressed in white combing her long hair.

There are tales of Banshees going back as far as Irish mythology is remembered and it is usually accepted that she is one of the fairy folk, although there are some who believe she is the ghost of a woman murdered or lost in childbirth, as was once all too common.

In painting this important character, it seemed obvious to me that we must observe her but remain unobserved ourselves. She faces away from us, her eyes perhaps fixed on the misty depths of the trees as she focuses on her task of conveying the sad news she is tasked with. I think she strikes a lonely figure, a singer of a song no one wants to hear.

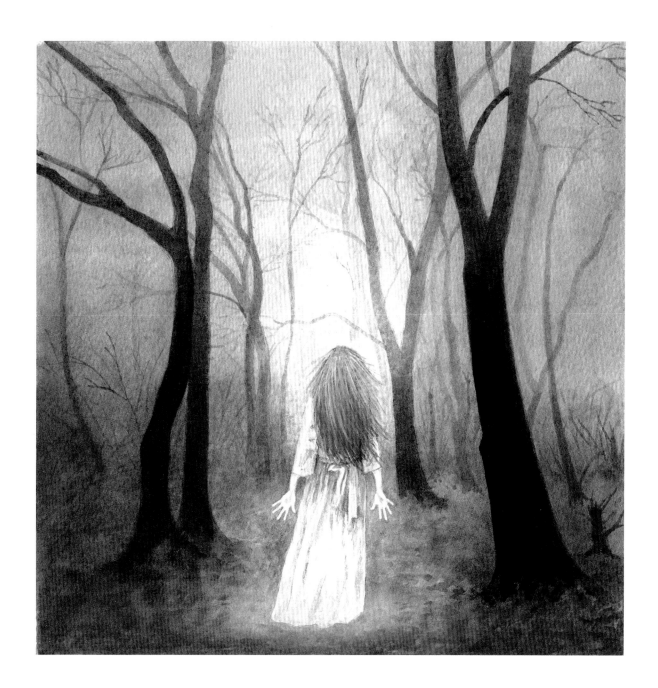

Northumberland Folk Tales

BY MALCOLM GREEN

'The Ballad of Tam Lin' is a song I have been familiar with for most of my life. It is famously very long, with the classic child ballad version having forty-two verses in total. It is a marvellously exciting story which centres on female daring and bravery, which makes it appeal enormously to young girls, when so many folk songs seem to be about male concerns. I never succeeded in learning it, but there is still time.

Tam Lin is an old fairy ballad from the borderlands, concerning a mortal woman who encounters a mysterious man in a forbidden forest. When she finds herself pregnant with his child, she seeks him out again and learns he is a mortal man, captive to the faeries and at risk of sacrifice as their tribute to hell. To rescue him, she must find the faeries at midnight on Halloween and pull him from his horse as the faerie troop passes by. She must hold onto him as he is transformed into a variety of beasts, or fire, or other dangers. She does so, and at the end of the tale the Faerie Queen speaks her wrath at the departed man, wishing she'd taken out his eyes or his heart to prevent his rescue.

By complete coincidence my son is called Tam, not after Tam Lin but because it is the Scots version of Tom, and this meant that we could reference both my Scots heritage and an old friend of his father's when naming him.

He also proved the perfect model for the passage from the story I chose:

Amongst the yellowing leaves of oak and elm, she saw him standing by the spring, a white steed by his side.

'I don't even know your name,' she said.

'My name is Tam Lin,' he replied.

'Why do you dwell in this place?'

'I have no choice,' he answered. 'I am held here.'

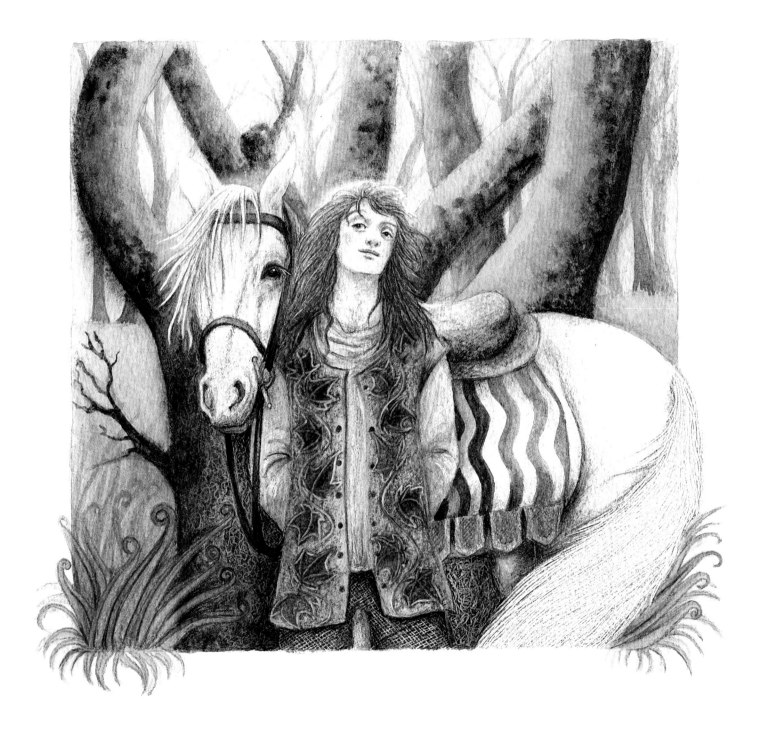

Essex Ghost Tales

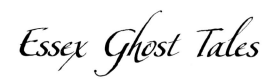

BY ROBERT HALLMAN

When The History Press asked me if I would consider producing cover art for their *Ghost Tales* series I jumped at the chance. There had been a couple of occasions when I had needed to pull back a little from exploring the darker side of my imagination while working on the Folk Tales covers, and illustrations for ghost stories would give me a chance to explore that territory.

Essex Ghost Tales was the first title in the series I received and was beautifully evocative of the odd spookiness of the marshes of the area, dotted with the remains of derelict boats and ships, slowly rotting down into skeletal offerings to the murky sky. The poem below, which opens the book, was in large part my inspiration for the cover.

The silence of death hangs over the marshes of Essex: the death of ships, the death of sailors, the death of times lost. This cover is more evocative of that mood rather than frightening, I think, but I would not like to be out in the marshes at night, all the same. As the author Robert Hallman puts it: 'A ghost-like figure, a silent owl and the bleached bones or beastly skeleton of a ship, or a coffin, or teeth …? in a cold blue eerie atmosphere, so right for the marshes about Essex and the Thames Estuary.'

'The Silent Fleet' by Robert Hallman

When night falls on the ancient coast
And stars abound, the sparkling host
Reflect in ev'ry ripple small,
The night owl hoots its eerie call
And quietness cloaks all.

Then rises proud a silent fleet
Of spectres from the muddy deep.
And all the ships that ever sunk
Or rotted on a muddy bank
Reclaim their naval rank.

As ghostly shadows. Floating free,
The lichen hulks take to the sea.
And masts appear where pennents flew.

From Davie's Locker climbs the crew,
And sails unfurl anew.

And black, barge black, the spritsails glide
From friendly quays on wind and tide,
From busy Harwich to the Nore,
From all around the sleeping shore
Collects the silent corps.

But none who sleep will ever see
The little ships take to the sea
And travel to a foreign strand
To pluck the soldiers from the sand
As brothers, hand in hand …

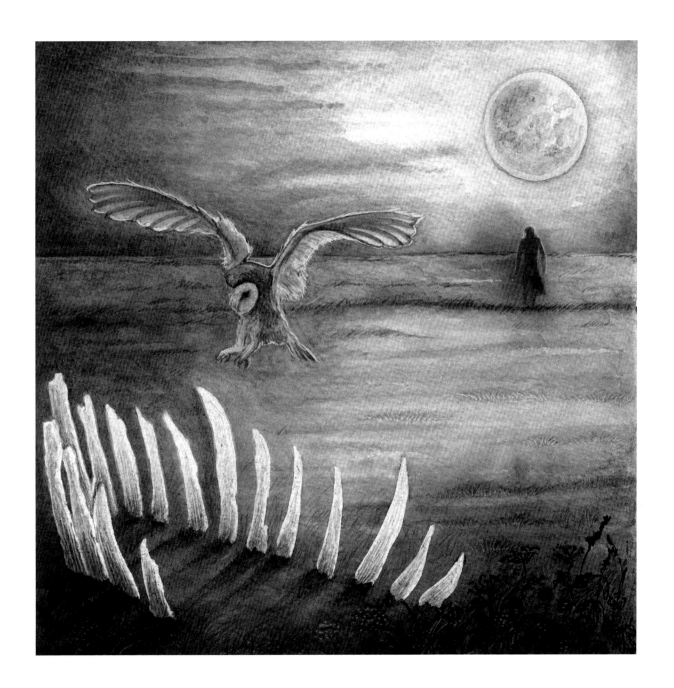

Leicestershire & Rutland Folk Tales

BY LEICESTERSHIRE GUILD OF STORYTELLING

The sister of Bran the Blessed, Branwen, was famed for her beauty and kind and gentle nature. The King of Ireland heard this and travelled to meet her and, if possible, make her his wife. The two met in the court of her father, and their hearts met too, so a marriage was arranged. But as with all these stories there is always the proverbial fly in the ointment and, in this case, it was Branwen's brother, Efnissien, a jealous and vindictive man who contrived to cause conflict between the two and their families.

The illustration depicts the moment when Branwen, rejected by her husband due to the machinations of her envious brother and forced to be the lowest servant in her own castle, sends a young starling she has befriended out over the sea to seek out her brother Bran and alert him to her plight. I used a photograph of myself as the basis for Branwen, something I very seldom do but this particular one seemed right. I don't know whether she had red hair (and I don't) but I have a penchant for redheads in my work, as you may have noticed, and it always looks good against a dark background and lifts an image that may otherwise lack something to instantly draw the eye.

Another reason for tackling this story, apart from its obvious beauty, was the opportunity to depict a starling. I have loved these glittery, sharp eyed and beaked little birds ever since I used to watch small regiments of them combing the green space outside my childhood home for insects and scraps. They have become ever rarer as the years have gone by and are seldom seen now where I live. But I was lucky enough to witness a murmuration, the beautiful flocking behaviour of starlings at sunset, where they move through the sky as though it were water and they a shoal of fish, massing and turning in endlessly changing patterns against the dusk. They are special birds, which I imagine is why one features in this story and is definitely why you see one here.

Down Folk Tales

BY STEVE LALLY

Down Folk Tales was an interesting one, where I let my love of the slightly macabre possibly carry me away long before I had a chance to legitimately indulge it on the *Ghost Tales* titles.

The cover as it appears on the book is not quite the one you see reproduced here; the carved Jack-o'-Lantern or 'Neepie Man', the model for which I discovered in an Irish museum and which reminded me so much of the turnip heads we had carved as children, was replaced with a Celtic carved head at the request of the author, who felt that it was just a little too creepy for the tone of the book. Looking back, I do understand his qualms, although I couldn't see what the problem was at the time and still find the Neepie Man fascinating rather than frightening, but perhaps as an artist you are sometimes just a little too absorbed in your work! You can now judge for yourselves. He is accompanied here by a traditional powder horn, like the one used by two mischievous boys in an attempt to scare 'Kate the Thresher', a formidable old lady in the story 'Auld Nick's Horn' as she ever after claimed it was one the Devil had lost during an attempt to come down her chimney.

The leaping figure in the sky is the marvellously wild and courageous Maggie, a famous County Down poacher who leapt to safety from a group of drunken soldiers across a seemingly impossible chasm, celebrated here in verse:

> The Mountains of Mourne, antique strange idylls
> Of Maggie's Great Leap and the dread Bloody Bridge
> Where thousands were slain for reading their bibles
> And thrown from the parapet over the ridge.

(From 'A Poetical Description of Down', by Joseph S. Adair, 1901)

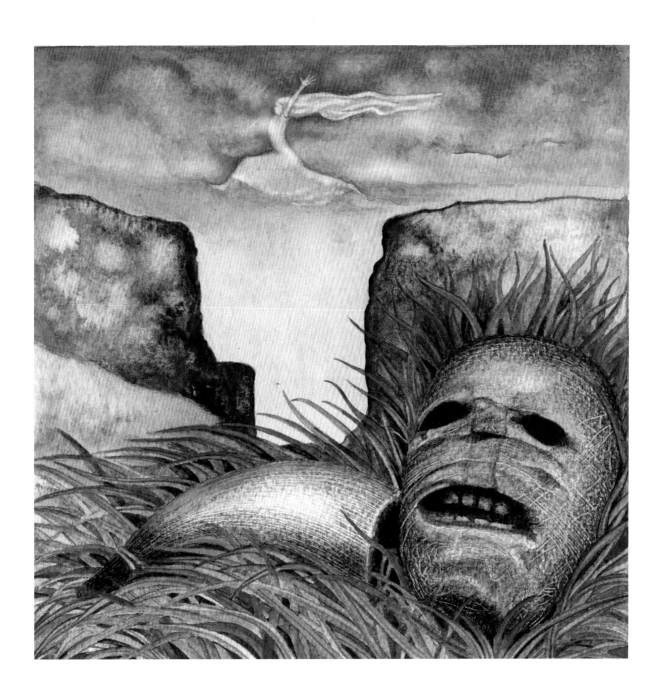

Louth Folk Tales

BY DOREEN MCBRIDE

They pawed the ground sending sods of earth flying through the air as they locked horns in battle. The Men of Ireland trembled as they listened to the noise. The bulls fought all night. At dawn the Brown Bull appeared in the west carrying the remains of the White Bull stuck on his horns. Maeve's sons rushed out to kill him in revenge but Fergus stopped them.

'Let the Brown Bull go back to his own country,' he commanded.

When I was a child my parents had in their record collection an album by Irish group Horslips called *The Tain*; this was my first introduction to the story of the cattle raid of Cooley and the fight between the two fearsome bulls across the Irish countryside. I listened to this concept album many times during my formative years and the image of the two battling bulls has always stayed with me.

When the text for *Louth Folk Tales* arrived, including a version of this story, I started to research it again and was intrigued by the story of how the two bulls came into existence:

He was originally a man named Friuch, a pig-keeper, who worked for Bodb Dearg, king of the Munster sidh. He fell out with Rucht, who was a pig-keeper for Ochall Ochne, king of the Connaught sidh. The two fought, transforming into various animal and human forms, ultimately becoming two worms which were swallowed by two cows and reborn as two bulls, Donn Cuailnge and Finnbhennach ('White-horned'). Donn belonged to Daire Mac Fiachna, a cattle-lord of Ulster; Finnbhennach was born into the herds of Queen Medb of Connacht.

So these characters had been fighting even before their birth as bulls. In some ways, the whole long and complicated tale of the Tain serves only to bring them back together again, to continue their dispute unto death.

So much fury, so much macho masculinity … did I dare to tackle it? You bet I did.

Drawing and painting this bull was one of the most unsettling illustration experiences I have had; he made me uncomfortable it's true, he is unequivocal in his maleness, but he also echoes something in me that is largely hidden – anger. This is an emotion I have never found easy to express.

Sometimes pictures take me on a journey. This one still does.

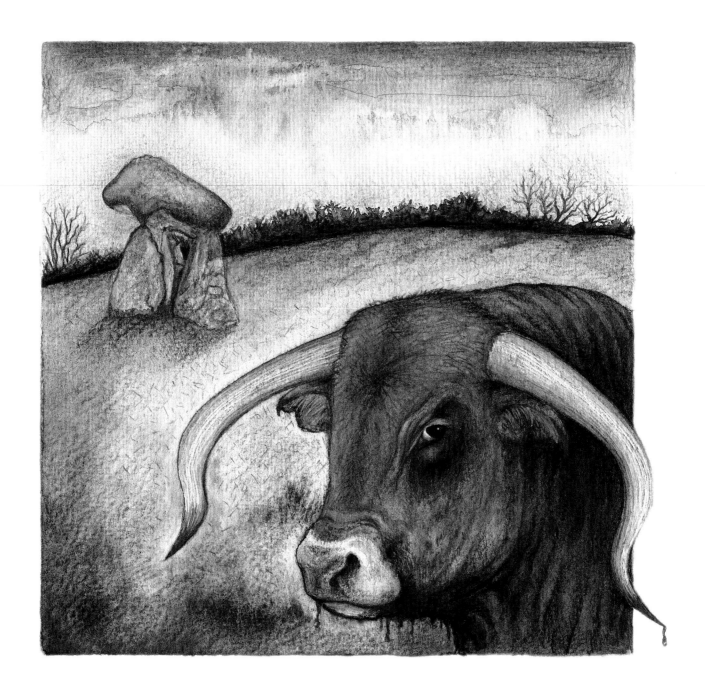

Denbighshire Folk Tales

BY FIONA COLLINS

I like dragons very much and nearly every book in the Folk Tales series features at least one dragon story. I chose to illustrate this particular one in part because he brought with him a chance to paint a red one and thus reference the iconic symbol of Wales, and in part because he has a little dialogue in the story and exhibits the same dry wit that Tolkien's Smaug seems to have been gifted with:

'How nice to have a visitor,' said the dragon. 'Now, do tell me, to what do I owe this unexpected pleasure?'

'Dragon,' declared Sir John, 'thy reign of terror has come to an end. I am here to vanquish thee. Prepare to die, for I have never yet been beaten in battle!'

'There's always a first time,' murmured the dragon, uncurling massively from where it lay beneath the Treasure House Tower, the Tower-next-Treasure-House, the Bishop's Tower and the Red Tower. It really was a big dragon.

Sir John does of course triumph in the end as this is a story told for a human audience, not one of dragons, but the dragon has the last laugh in that his power in popular culture persists to this day and every time we see the Welsh flag, we are reminded of his historic place in British history.

The oldest known use of the dragon to represent Wales is from the *Historia Brittonum*, written around AD 830, in which the text describes a struggle between two serpents deep underground, which prevents King Vortigern from building a stronghold. This story was later adapted into a prophecy made by the wizard Myrddin (or Merlin) of a long fight between a red dragon and a white dragon. According to the prophecy, the white dragon, representing the Saxons, would at first dominate but eventually the red dragon, symbolising the Britons, would be victorious.

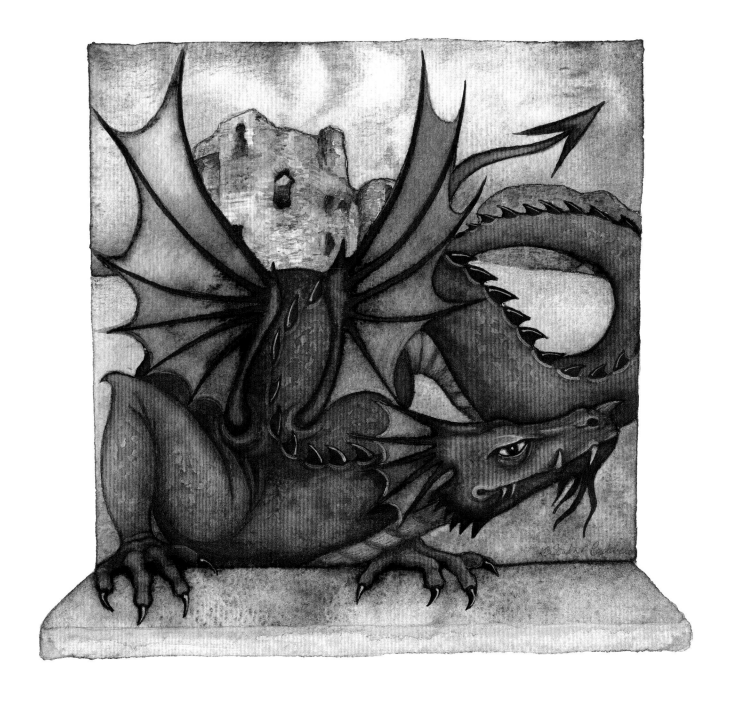

Midwinter Folk Tales

BY TAFFY THOMAS

There were so many beautiful stories and rhymes in this book that I couldn't choose just one. Also, I have a Christmas tradition of my own of arranging seasonal decorations into little compositions that I find pleasing, so with that in mind I picked out six tales that could be put together into one picture that would happily evoke some of my own feelings about the season and hopefully other people's too. They are:

A warm glow
The legend of the Robin
The dragon of winter
Wassailing
The twelve months
Room for a little one

You will have to read *Midwinter Folk Tales* to find the references, as I don't have space to explain them all here and it really is a lovely book, but the dragon of winter was a particular favourite of mine here. This story of the people of Cumbria persuading a recalcitrant dragon to go elsewhere for half of the year to allow them a summer is evocative of so many ideas about winter and weather that prevail all over the folk-tale globe. In Chinese folklore dragons are the primary controllers of the elements and although usually benign, can also be rather awkward with humanity. I used a window space and the view through it as a way to tie all of the elements of the tales together into one unified image and to try to convey the feeling of tales told in the warmth during the dark season.

 Winter for me is about the warmth and light inside countering the cold and dark outside. This is especially true when you live somewhere, as I do, that gets almost no sunlight in midwinter due to its geography. We have a very real sense of that ancient fear that the light, once gone, may never return and keeping that glow going is essential for hope in the new year. I hope this image embodies that hope.

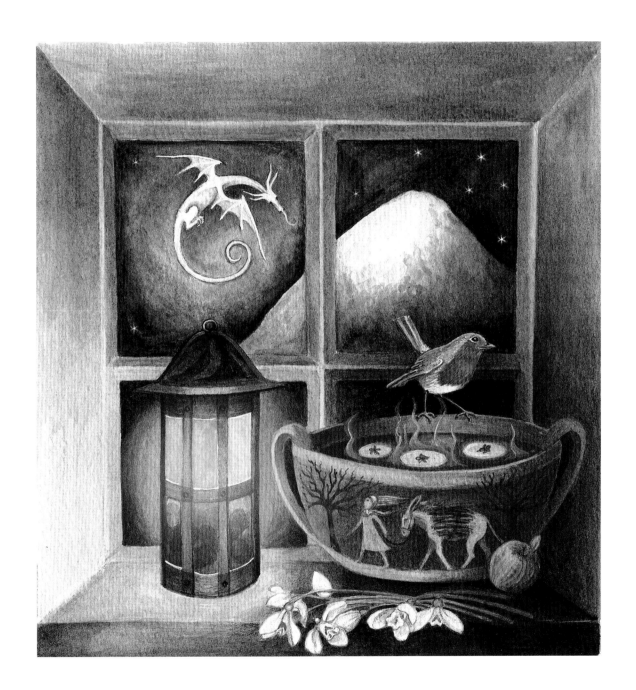

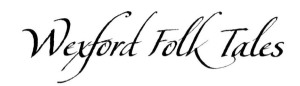

Wexford Folk Tales

BY BRENDAN NOLAN

The moon shone coldly on the sea and on the land, on dark faces in the fishing-fleet and pale ones ashore, as seaward went the thrusting boats, and heavenward went the cries of keening wives and mothers.

The nets had scarcely sank an inch below the surface when the boatmen on the water were astonished at what they saw rising from the sea before them. It was a human shape arising from the sea, warning them with upraised hand to go back to land.

It fell away below them into the fathoms of water. As they watched it gleamed whitely through the water, and frowned up at them. They saw its white hand clenched above it, as it sank slowly down in silence.

And so the terrible tragedy of St Martin's Eve unfolds, as the fishermen ignore this last of several warnings not to fish the huge shoal of herring that appeared offshore in 1698. Seventy families lost loved ones that night, and no fishing boat puts out from Wexford harbour on that day, even now.

The vision of the messenger sinking despairingly beneath the waves as his last warning goes unheeded could be of St Martin, or maybe even Manannán of the waves. Whoever he is, he tried and failed to get all but one of the fleet to turn back that night and those who remained to fish were lost.

This illustration was a tricky one. If I wanted to have him sinking beneath the waves in a dynamic and interesting way it needed to be from above, which meant I needed a model and a camera. I settled on Bill for this one, he had the right look (and could be persuaded to stand in a stairwell being ordered about).

The whole image was executed in Inktense apart from a little silver on the herring, and also needed masking quite a bit, another process which I occasionally dread. But it was worth it. Pushing yourself to do the difficult thing often yields the best results.

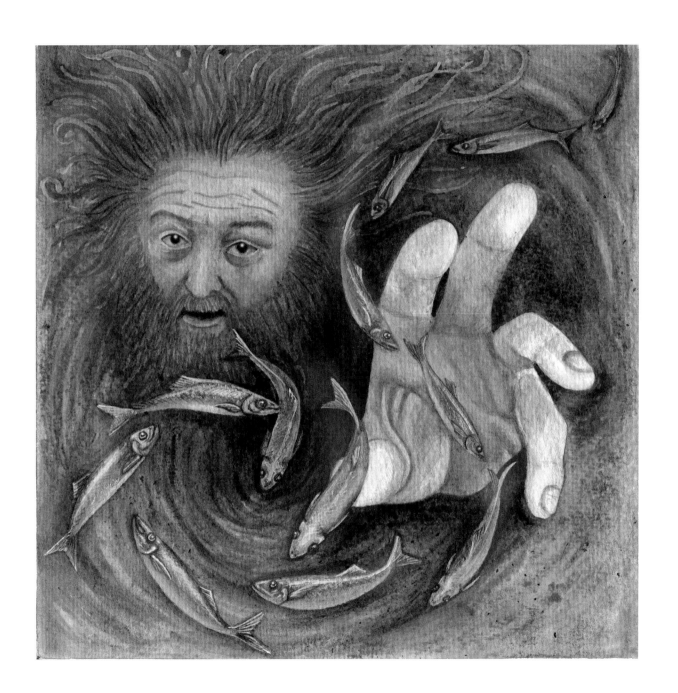

Where Dragons Soar

BY PETE CASTLE

I chose the ballad of Reynardine for my cover image almost immediately when I read the manuscript for *Where Dragons Soar*, but felt I had to consult author Pete Castle before I began the piece as it was a song rather than one of the many brilliant stories in the book. Pete said, 'Yes! That would be great! Can you put him in Whitby too?' So an idea was born …

I first heard this ballad on Buffy Sainte Marie's *Fire & Fleet & Candlelight* album when I was very young and was reminded of it years later when I saw the film adaptation of Angela Carter's *The Company of Wolves*; the combination of dangerous males and shapeshifting is always an intriguing one for me.

I have recently started to do some of my initial composition work in Photoshop, if I know what elements I want to include but am not yet sure what I want their relationship to be in the final image. I can play with scale and proportion by combining sketches and photographs in layers and it was a very useful technique here.

Because he was going to be placed in a Whitby setting there was also the vampire connection to be played with a little, so I found a vintage photo of a rakish gent I was hoping would not look altogether out of place in Whitby at certain times of year and photoshopped a fox head onto his shoulders. I tried a few different ones but eventually settled on one with a particularly penetrating stare looking directly at the viewer. With the addition of Whitby Abbey in the background and a sky from one of my own source photos, I had my composition sorted and could begin to paint.

I form a relationship with all of my cover characters during their creation and this one was not an easy one for me. I had to put him out of sight between sessions as he rather unsettled me (he still does a bit) and I was glad to finally send him off to the publisher! The observant among you will notice I added a tiny dragon to reference the book title – you have to look to spot him though …

Author Pete Castle said the following:

I've been trying to think of something interesting and original to say about the three covers you've done for me … but can't. I love them and they are always a talking point. Is that Whitby on *Where Dragons Soar*? It couldn't really be anywhere else could it! I was really pleased that you leapt at the opportunity of illustrating Reynardine at Whitby for that cover, it was just what I always see when I sing it and everyone seems to love it. I'm sure I've sold copies just because of the covers. I look forward to your book!

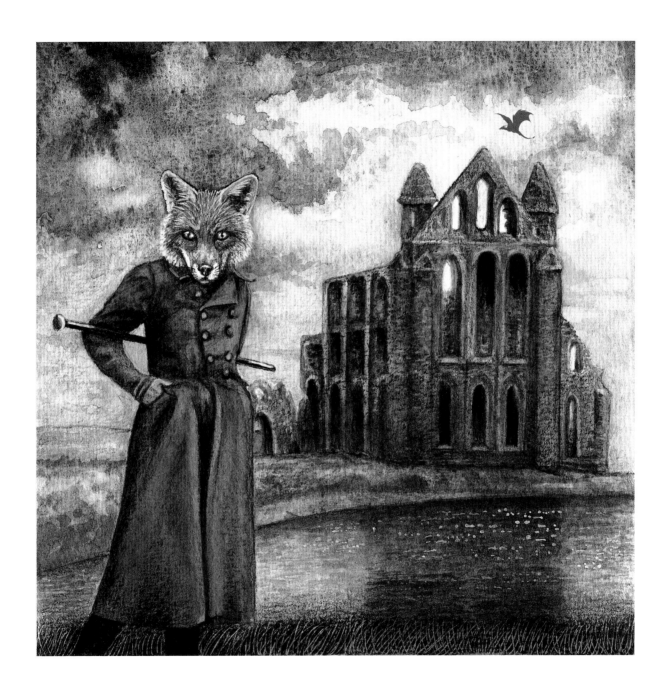

Gloucestershire Ghost Tales

BY ANTHONY NANSON AND KIRSTY HARTSIOTIS

The inspiration for this cover was primarily a heartbreakingly sad story rather than a scary one, the tale of the ghost of a bear that haunts the countryside around Campden in search of the gypsy master he loved, who had promised him a return to life in the wild before dying himself of a fever and leaving the bear to dance for men who had no tenderness in them and didn't play the tunes he knew:

> In Campden no one knew for sure the bear's final fate. Some said he turned savage and had to be shot; others that he died of a broken heart. The following February, when again the snow lay hard and white on the hills, strange reports began to come from the vicinity of Heavenly Corner and Blind Lane. Glimpses after dark of a shaggy shape snuffling about with slow, shambling steps. Dogs would flee yelping to the other end of town. The sightings continued over the years. As late as the twentieth century that shambling shape was seen near where the bear and the gadular had slept side by side, walked down Blind Lane, beheld the view across the hills, and the man had promised the bear that someday he'd wander wild and free.

The face in the tree comes from another story in the book. A knight is waylaid by a strange and seductive female spectre on his way to collect holy water to save the life of his sweetheart. He resists, but the damage is done and his love dies:

> His breath stopped as she reached out to him, and she was cold, colder than the mist, colder than ice, freezing him to the spot as she cooed to him: 'Come to me, my lover, come to me, red cross knight, lie down in the forest and be with me …' Her glowing eyes compelled him closer. Her fingers caressed the silver flask hanging from his belt.
> Aldred's knees grew weak as he yearned towards her, the pulse of his desire was hot under his skin, and she was leaning in, her lips pouting to kiss.

The face in the tree is from one of my favourite sources for vintage portrait photographs, the Anonymous Photography archive.

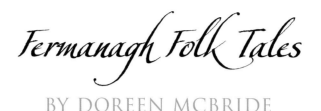

Fermanagh Folk Tales

BY DOREEN MCBRIDE

I have read quite a few stories about Badb, the Celtic Goddess of War, sometimes also associated with the Morrigan.

Here she pops up in a story called 'The Defeat of Lough Erne's Pagan Gods', a story which I found rather sad, as the pagan gods are portrayed as demons, as is necessary in this Christian narrative, but the truth of their extinction and loss is still poignant to me. Even Badb, once so powerful that she could turn the course of battle for the Tuatha de Danaan, becomes nothing more than a story for scaring the nervous:

He went to the edge of Lough Erne after dark and stood looking across its still waters. They appeared very peaceful in the moonlight. It was difficult to believe demons lurked beneath the dark surface and that all the islands bear traces of their pagan past. He shivered as he remembered the horror associated with Boa Island, also called 'the Island of the Scald Crow'. It is named after Badb, the Celtic Goddess of War, who often took the shape of a crow. During battles she caused the enemy to become confused so her side always won. Battlefields became known as 'The Land of Badb' and Mo Laisse realised he was facing a battle he was unlikely to win. He attempted to calm himself by looking up at the stars. They appeared like countless tiny white specks shining high in the heavens. 'I wonder,' he thought, 'if they really are souls of the faithful looking down.'

He does of course triumph, as this is a story of the power of the new god. But I have a lasting affection for the old ones too.

Badb was the daughter of either Cailitin or Ernmas, who was one of the Tuatha de Danaan. As a form of Morrigan, she was capable of changing shape at will, and she most often took the form of a hooded crow, although she could also appear as a wolf, a heifer or bear, or a female giantess.

Author Doreen McBride was at first rather uncomfortable with my choice of Badb for the cover image, but we corresponded by email and chatted about her and although she still refers to her affectionately as the 'scary witchy woman' she sent me this: 'Thank you, Katherine. She's lovely. She didn't scream "Fermanagh" at me in the beginning, but I've learnt to love her.'

Wrexham Folk Tales

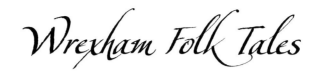

BY FIONA COLLINS

The story of a group of King Arthur's knights, rescued from a terrible fate when they become lost in a fog-drenched swamp as they travel back towards Camelo,t is unusual and unique, combining Arthur's knights (very much alive and not slumbering under a hill somewhere, as they so often are in British folk tales) and a strange white lion, a creature of the fairy folk of Wales, the Tylwyth Teg.

I wanted Arthur to be there too, in this strange mist-shrouded place, so although he is not mentioned in the story specifically I decided he would be the leader of the group, faced with the choice of whether to follow and trust this otherworldly creature or condemn his men to almost certain death in the treacherous bog …

They stumbled on, cold, frightened and wet, leading their equally miserable horses through the endless swathes of boggy, reedy ground. Water swelled up to fill hoof and footprints, as soon as each foot was freed of the deadly sucking kiss of the mud. They had no idea of where to go or what to do, knowing only that they must keep moving or sink inexorably into the slime. They expected the worst.

Gradually they made out the creature: it was not a disembodied mouth, as at first it had seemed to be, in the drifting mist. It was a white lion, huge in size, which seemed to shine and shimmer in the darkness, as though it exuded light from within. Its eyes were red, and so, they saw, were its ears.

Getting the lion to look suitably otherworldly was difficult; I wanted it to have the feel of something almost there, but not of this dimension somehow. This proved tricky, and mist was also added and removed several times as I wrestled with it. I think in the end the illustration works, but maybe dusk or even night-time would have made a better setting.

Laois Folk Tales

BY NUALA HAYES

I loved the imagery in the story 'Fionn Mac Cumhal and the House of Death' – the depiction of the truths we all have to face as mortal beings engaged in relationships with each other and with the genuinely otherworldly if we stumble into their realm is brilliant. And the suggestions of religious iconography were always at the edge of my consciousness here too.

This composition originally included an image of the old man in the story who represents time, but try as I might I could not get the balance and the feel of an icon that I was looking for with another figure, so he had to go. The figure of youth dominates utterly here, she holds your gaze with her chin tilted defiantly as only the young can, she is framed as an icon, youth being that golden time for so many that we only appreciate in retrospect and are careless of while we travel through it just as Fionn and his men were. Life and death face one another down: both will always be simultaneously triumphant and defeated as they circle each other forever.

Author Nuala Hayes had this to say:

Anyone who has contributed to The History Press' Folk Tales series will remember the day when Katherine's cover illustration came winging as an email attachment, through the wonder of cyberspace, and you see for the first time the illustration she has imagined for one of the stories you have included in the collection. In my case I was astonished at the image she had chosen from *Laois Folk Tales*, 'Fionn Mac Cumhal and the House of Death'. Katherine Soutar's work is far from the swirling clichés of Celtic illustration. You know them, all inspired by Jim Fitzpatrick and Horslips. Katherine's work is stylised but it's also rich and real. Her depiction of Youth in the story, with a clear, pale, solemn face framed by startling red hair offset by a golden halo as in an icon against a stone wall, was a perfect image for the young girl who so enthrals the warriors, Fionn and his mates.

It reminded me of Leonora Carrington's Giantess in Youthful Form. The white lamb and the black cat depicting life and death are realistically drawn, each with just one eye visible, deep and fathomless. Fascinating.

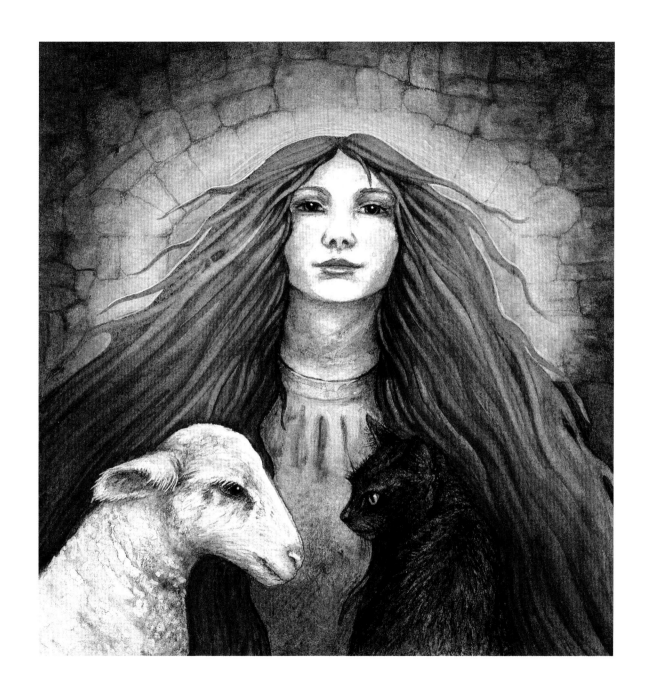

Midlothian Folk Tales

BY LEA TAYLOR

When I came across the story of the discovery of the tiny coffins in the text of *Midlothian Folk Tales* I had a feeling I was going to use it … I was even more sure when a Google search turned up more background on the story and tantalising images. Most of the following information is from the National Museum of Scotland's excellent website and I recommend you visit it for more.

In late June 1836, a group of boys headed out to the slopes of Edinburgh's Arthur's Seat to hunt for rabbits. What they found there has remained a baffling mystery ever since.

In a secluded spot on the north-east side of the hill, the boys discovered a small cave in the rock, hidden behind three pointed slabs of slate. Concealed within were seventeen miniature coffins.

Eight of these coffins survive to the present day, and are on display in the National Museum of Scotland. No one knows what happened to the other nine or what their original purpose was, theories include witchcraft, honorific burials and some strange tribute to the victims of Burke and Hare, Edinburgh's infamous bodysnatchers. Burke and Hare murdered seventeen victims and sold their bodies to the surgeon Robert Knox for dissection during a year-long spree in 1828.

But the truth is that no one knows who made them, who placed them there or why, but every tiny doll is different and their expressions and demeanour are fascinating. I depicted just a few with Arthur's Seat in the background, silhouetted against the sunset.

And so the story stands: a mystery that will probably never be unravelled but which has captured the imagination of countless visitors to the National Museum of Scotland.

Dead and buried? Not quite.

In December 2014, the museum received a mysterious package: a beautifully made replica of one of the coffins, cryptically entitled 'XVIII?'.

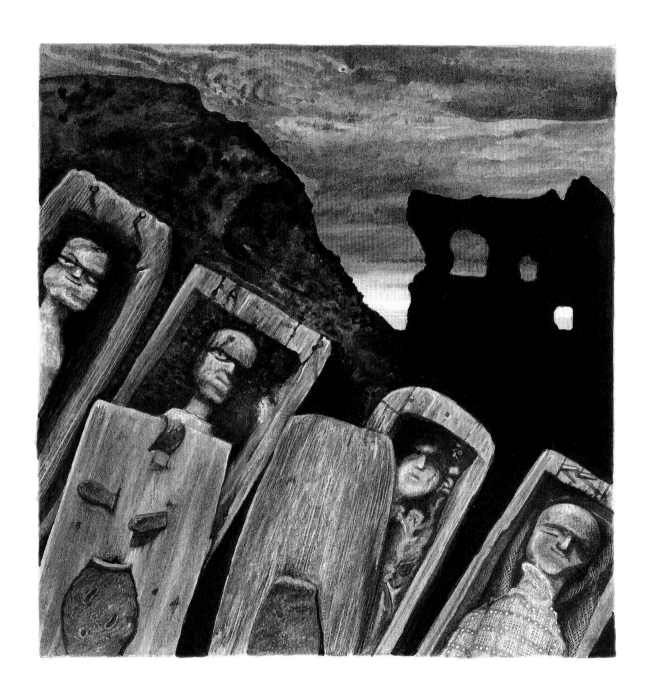

Dancing with Trees

BY ALLISON GALBRAITH AND ALETTE J. WILLIS

When I received the text for this book – the third anthology of folk tales I worked on for The History Press – and saw the title, it seemed obvious to me that it should be echoed in the cover art (dancing and trees both being personal passions of mine as well).

The story the title springs from is 'Jack and the Dancing Trees', the last in the book, and is a traveller's tale from Scotland, my dad's home country:

> She nodded her head wisely. 'I've heard tales that the big old oak tree up there pulls himself out of the ground every hundred years on Midsummer's Eve and goes dancing with the young birch maidens that grow so coyly around him.'

Jack is the Everyman character in folk tale, and in this one he hopes to retrieve treasure from the hole left when the huge Croovie oak goes dancing with his birch ladies so he can court his Jeannie.

The oak and the birch are two of our most familiar native trees in Britain, and the great oak is indeed a purveyor of great treasure in that it supports the largest community of organisms of any tree in the British Isles and is therefore one of the most valuable members of our countryside.

Making trees dance, however, is not all that easy, my early sketches made me wince with their woodenness … oh the irony! But eventually I found an image of trees in a Polish forest that had grown into distorted shapes due to some strange environmental factors and they formed the basis for my frolicking birches. The oak is only seen in part as I wanted to emphasise his size and if I had drawn all of him the other trees would have been tiny by comparison. The slender birches, therefore, are my main focus and they are clearly enjoying themselves a great deal as the oak looks on.

And does Jack find his treasure? You will just have to read the book to find out …

Wicklow Folk Tales

BY BRENDAN NOLAN

The Sally Gap in the Wicklow Mountains is the setting for this illustration, which contains probably my favourite hare of all the ones I have painted and drawn over the years and here are the lines that made her happen:

> They met multitudes of Irish hares running around, though at a distance from them. The same hares can look enormous in a mist when it swirls about their legs. Their long shadows often give rise to stories of strange beings flitting through the landscape. Some sit up on their imperious ends against the skyline, like lords of the realm, and stare at people as they are travelling by.

The otherworldliness suggested by this passage sums up so many of the things I have always loved about the hare, about wild things in wild places, and all the creatures that we barely understand and seldom see.

The other feature of the picture is the Féar Gortach – the hungry grass – generally accepted to be like quaking grass in appearance but this small and delicate wisp of life has a number of fearful legends surrounding it, all of them explanations for the overwhelming feeling of lassitude and despair that overcomes those unlucky enough to step or sit on it while out walking in the mountains. Many of these stories are associated with the Great Hunger of the 1840s, when so many perished beside the pathways from hunger and exhaustion as they walked from one place to the next in their desperate search for food:

> The hungry grass grows where victims of the famine fell down for the last time, their mouths stained green with the nettles and grass they had eaten in their starving dementia as they fought unsuccessfully for the life that was leaving their bodies. The spot where the hungry grass grows is where their mouth last touched the ground, so the old story says.

Their sad spectres are never far away in the lonely hills.

'I did it,' he breathed heavily and quietly.

He strapped the sword to his side and put the helmet onto a large and vicious looking horn on the worm's head. The boy then staggered back to the castle dragging the huge head by the other horn.

It took an age, but eventually he made it. The farmers in their fields saw him first. Then the word spread across the whole of Storkburn. Here was John Conyers, the slayer of dragons. The boy dropped to his knees and held the sword to the sky.

Although the tale of the Lambton Worm is much better known in the county of Durham, I decided to illustrate the story of the Sockburn Worm partly because the hero in this case is just a boy when he defeats the fearsome worm (with the help of a wise woman, of course) but also because it was thought to be the tale which inspired Lewis Carroll to write *Jabberwocky*, a favourite poem of mine renowned for its imaginative language and rhythm.

A little online research uncovered the rather beautiful carved figure on the coffin of Sir John Conyers in All Saints' Church in Sockburn, and I decided to use this as the basis for my illustration and incorporate the dreaded worm into the carving somehow.

I wanted to retain the feel of stone so decided to render the entire piece in one shade of Inktense. I soon realised that the lack of any contrasting colour at all was a problem, as the illustration needs to 'pop' a little on the cover to attract attention. So I looked at the text again and found the story of the Stanhope fairies, which contains this passage of advice to a father about how to rescue his daughter from the fairy folk:

'Go to the cave of the fairies. Take with you a branch from the rowan tree, that will protect you.'

Finton nodded.

'But to win your daughter back you will need three things. You need to take a light that does not burn, a chicken with no bones in its body, and an animal that will give you part of its body without losing a drop of blood. If you do this then fairy law says that your daughter must be returned to you.'

Here was the solution to my problem – these items would also feature on the cover to add that pop of colour needed to draw the eye. And I like riddles …

My depiction of the worm owes a lot to my thoughts about how the Jabberwocky might look and also time spent looking at creatures that lurk in the deep oceans, a fantastic source for alien life forms of all sorts. Everything else in the image is depicted as realistically as possible so you believe in the worm too, hopefully.

Tyrone Folk Tales

BY DOREEN MCBRIDE

The legend of the Creagan White Hare is not specifically one of shapeshifting but the underlying suggestiveness of it in the tale and the song caught my interest … I also love hares of all sorts – as you know by now – and there is something very definitely not of this world about them.

This big and bold white hare that evaded even Pat Devlin's famous dog Black Nell seems to have more than a bit of the magical about her: some did think that perhaps she was a witch, others saw her as a symbol of the Irish rebel that always escaped the authorities.

There is a stuffed hare displayed in the Creagan Centre (although we know that can't be her, of course) and a large sculpture of her in a field on the road to Gortin.

The verses of the song were penned by John Graham and set to music some fifty years later. Now every school in the area has it on the curriculum. These are my two favourite verses:

> One day John McKenna was digging some ground
> And was greatly surprised when the White Hare came round
> Said she to McKenna, 'Who's your man with the dog
> Don't you see him there yonder coming through the Black Bog?'
>
> McKenna looked up, stuck his spade in the ground
> Says he, 'That's a poacher called Jimmy McKowan.'
> 'Ah well,' says the Hare, 'I can sleep snug and well
> I thought it was Devlin with bonny Black Nell.'

I wonder what surprised McKenna more, the appearance of the famous hare or the fact that she asked him a question?

While sketching this one out I came across some lovely landscapes where the trees were rendered in white against the sky, and decided to use the same device. The white hare runs across the foreground looking at us as she passes, the dog stands silhouetted against the sky, looking the wrong way. We are quietly satisfied with that as we know whose side we are on …

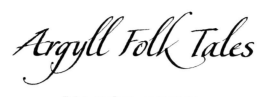

Argyll Folk Tales

BY BOB PEGG

The cover of *Argyll Folk Tales* is taken from the story 'The Islay Water Horse'.

Water horses in Scotland can be either kelpies or the each-uisge, closely related shapeshifting water spirits with malicious or at the very least mischievous intent.

In this story, rather unusually as they usually appear alone, there is a whole group of them and their intent is undoubtedly evil. They are, however, outsmarted by a young woman who not only seems to be possessed of nerves of steel and is marvellously quick-witted but also knows her Homer and some magic. I was instantly drawn to her.

The story takes place on a lonely island where she has been left alone minding the cattle while the man is away on the mainland, and when I read the description of the water horse as having a face that was 'skinless and raw' I began to envisage him as something anatomical, perhaps even skeletal, and my sketches focused on ideas of vaguely human anatomy with a horse head or skull.

For *Odyssey* fans, I reproduce here the paragraph which made me exclaim 'Yes!':

The stranger lumbered towards the fire, and asked the girl her name. 'Mise mi Fhin, she told him. 'Me myself.' The thing grabbed hold of the girl. She picked up a ladle full of boiling water and threw it over him, and he ran off shrieking into the darkness. The girl heard a hubbub of unearthly voices asking what was the matter and who had hurt him. 'Mise mi Fhin, Mise mi Fhin!' – 'Me myself, me myself!' – cried the monster, and his companions let out a howl of mocking laughter.

Many of my early versions had to be rejected, as making him too concrete and visceral proved both compositionally tricky and took the feel of the illustration too far in the direction of horror for a Folk Tales cover. So I decided to focus on my bold and resourceful heroine and relegate the monsters to shadowy figures in the background. She stands in the cold light of dawn, pale and defiant, looking straight out at us having survived the night alone, although she had to sacrifice one of her cattle to do so. She still holds the stick in her hand that she used to draw a protective circle around herself. When I was in the process of painting her, on her cheek there somehow appeared a tear, which I later chose to remove; it may just have been caused by the wind anyway …

Hampshire & Isle of Wight Ghost Tales

BY MICHAEL O'LEARY

I chose the following passage from 'The Ghost Island' – a marvellously hair-raising tale of drowned mariners haunting a churchyard and taking part in a ghostly burial ceremony – for its details about sea wrack and limpet shells and also because there is something so sad about the souls of men drowned at sea and never seen again. My grandfather was a sailor and his family believed him lost for some time during the Second World War, which must have been heart-breaking.

As he sat frozen on the gravestone, the figure of a mariner hove into view. At least it looked like a mariner, or a monster – or a drowned mariner. It was beating the drum, it had on the clothes of an eighteenth-century sailor, and it was all festooned with seaweed and sea wrack, and there were limpet shells on its skin, and its eyes shone in the darkness like pale yellow lanterns.

In researching how to portray the face of a man who has been dwelling in Davy Jones' locker for a while I turned to a favourite grisly practice of mine, that of the casting of death masks of the famous or criminal. When I came across the death mask of the eighteenth-century German poet, writer and natural philosopher Johann Wolfgang von Goethe, I felt it was perfect to use as the basis for my drowned mariner, and so it proved. I decided to leave the eyes closed in the end as I wanted the end result to have a more spooky pathos than downright scariness.

Behind this apparition there appeared two more, and they were carrying between them something sagging and dripping water, something wrapped in sailcloth.

Then, behind them, there was a drowned mariner playing a mournful tune on a squeezy box, and behind him a pale woman who moved slowly and gracefully, as if her body was animated by the movement of the sea.

The first mariner started to speak, in a voice from close by and far away: 'We commit this body to the deep, to be turned into corruption, looking for the resurrection of the body, when the Sea shall give up her dead …'

I do hope Goethe would have appreciated being used in this way, I haven't heard from him as yet …

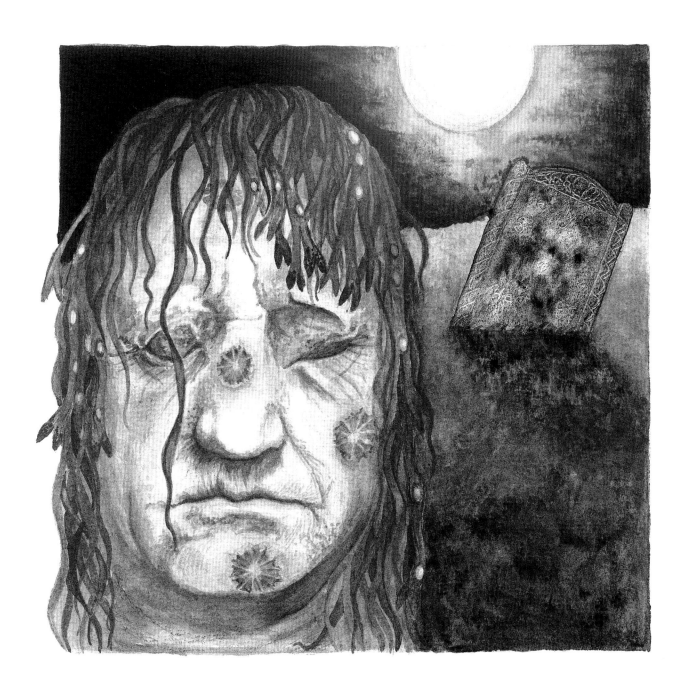

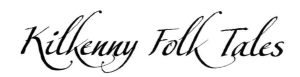

Kilkenny Folk Tales

BY ANNE FARRELL

There are numerous stories of werewolves but the one in this book is unusual. Nobody really knows how old the story is but it seems to date back to the ancient lands of Ossory which incorporated modern-day Kilkenny and Laois. There are a couple of stories that blend and interlock about their origin.

It was said that the people of Ossory had the ability to transform into a wolf whenever they pleased. Possibly these folk were descendants of the Laignech Faelad, a tribe of fierce warriors whose services in battle were not only highly sought after, but who refused to change to the new religion and were then slandered and condemned by the Catholic Church as bloodthirsty monsters. St Patrick apparently was so incensed by their defiant behaviour that he cursed them personally … I have found him to be rather an easily annoyed saint on the whole, though.

It was said that once these Ossorians took the form of a wolf, their human selves would remain in their homes in a deathlike, comatose state until such a time as they would return to claim them. Disturbing the human form was strictly forbidden, as it was believed that if a body was disturbed then the person would never be able to return to their true form and therefore be forced to live out their lives as a wolf.

Another version of the legend states that the people of Ossory lived under an ancient curse. Every seven years, one male and one female had to change into wolf form and live as wolves. Once the seven years was up, if they had survived unscathed, they could return to their village and resume their human form, and then another male and female would have to take their place.

At the end of the story, author Anne Farrell notes:

I have always had a fondness for wolves and their care for their own pack. Once, a long time ago, I dreamed that a wolf came hurrying from a great distance to warn me that a grandchild was ill and I never questioned it but woke and lit a candle and prayed. In the morning when I checked with the family it was indeed so. Perhaps there is more to transformation and other lives than we know.

Anne and I sadly never met, but I know she is much missed, and as for her thoughts on this? I would tend to agree.

Fife Folk Tales

BY SHEILA KINNINMONTH

According to legend a white stag roams the woods on the Strathtyrum Estate near St Andrews, and if you are lucky enough to meet him he might whisk you off to meet the fairies who live in the fairy knowle on Kinninmonth Hill.

When I saw that the author's name was also Kinninmonth, I couldn't help but wonder whether there was some connection between her and the fairy stag of the hill, and when I read through the story I was taken with the idea that the wee girl she spoke of might somehow be her, in her imagination at least. I think this little girl is all of us really, at that time in our lives when curiosity is dominant over fear and we would without question run out to greet a stag in the moonlight …

There once was a wee girl staying with her grannie who lived in a cottage in the woods. It was the first time she had stayed there so she was really excited and a wee bit scared because she had been brought up on fairy tales so she knew that sometimes things happened to folk who stayed in houses in the wood.

Through the night she heard noises so she got up to look out of the window. That's when she saw it.

She knew it was a deer because she had seen pictures but she'd not seen one like this before. It was pure white and it seemed to be looking straight at her. So she pushed her feet into her baffies, threw on her jacket and slipped out the kitchen door. There it stood, almost shining in the moonlight. She stretched out her hand to stroke it and before she knew what was happening she was up on its back and they were flying through the woods, over the burn, over the top of Drumcarrow Crag till it set her down on the slopes of Kinninmonth Hill.

Over the years I have seen a number of images of fairy stags, where their antlers grew like the branches of trees as though they had been born directly out of the forest, and this image is also echoed in one of my favourite films. *Princess Mononoke* features a forest guardian which also resembles a stag with tree-like antlers and I wonder whether this image is one that symbolises the beauty and mystery of forests everywhere, somehow.

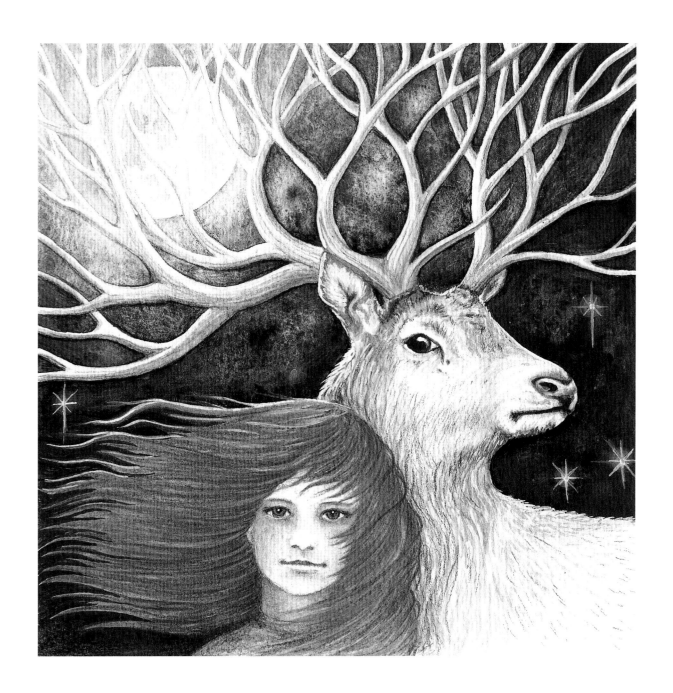

Galway Bay Folk Tales

BY RAB FULTON

The swan's form was now nothing more than a beautiful cloak, which the woman folded with great care and placed on a rock at the water's edge.

The story of 'Connor and the Swan Maiden' in *Galway Bay Folk Tales* is reminiscent of many of the selkie tales I know, wherein he manages to steal her cloak and so she has to go home with him. But in this story she does not leave him, primarily because she craves her former life in air and water, but also because he breaks his promises to her.

This was an image that sprang into my head more or less exactly as you see it here, it was just a case of getting her down onto paper the way she looked in my head. There is something about this picture that caught me. As soon as she was complete I took her to be scanned and then immediately framed, I knew I needed to see her every day still.

When I emailed author Rab Fulton during the writing of this book I received this reply:

Your illustration added so much to the *Galway Bay Folk Tales* book, and it still inspires me it is so beautiful.

I recently showed your illustration to a women's group in Galway. The group is made up of a mix of Traveller and migrant women. I work with them to help them create stories for their children and friends. Anyway, I wanted them to begin talking about folk tales. I deliberately chose not to tell them the story as I wanted them to make their own story using their own ideas and experiences. Instead I showed them your illustration to start a conversation going – and they were awestruck. It was incredible how your illustration really touched something in them and ignited their imaginations. So they've been working on a new swan maiden story, which we hope to publish. If you'd like to see a draft of that, give me a shout and I'll send it on to you.

This illustration, perhaps more than any other, has the power to give birth to her own story now. I look forward to reading the new one.

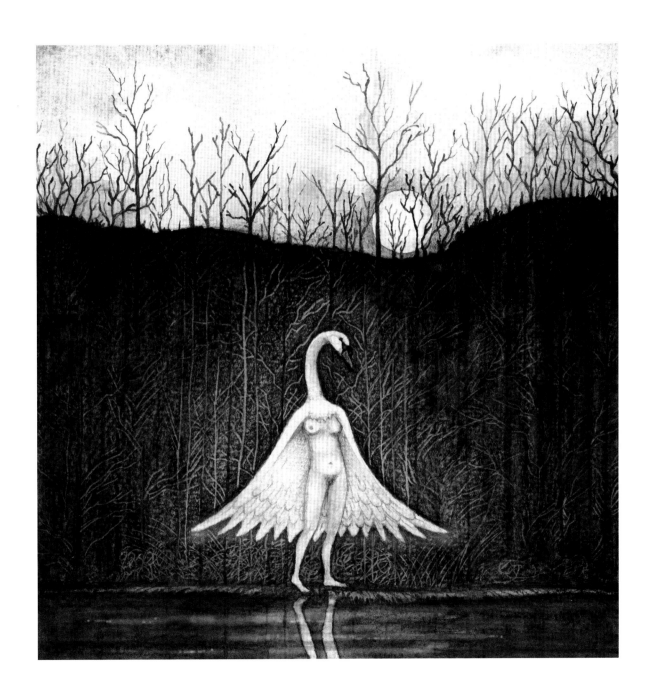

The Anthology of English Folk Tales

When this text arrived and I realised it contained several of my favourite stories, ones that I had already used for cover images, I thought it would be a great opportunity to produce a composite image of some of them. I was so enamoured of this idea that I did not stop to think about what other stories the book contained or whether it was really the right approach to take. I spent many hours learning how to use a graphics tablet properly and blending three of the book cover stories contained in the text into a single image.

I sent it off to the publisher. Silence. Then an email saying it wasn't quite what they had in mind – they thought a landscape of some sort would work better and could I please look at doing something different. I was, briefly, devastated.

But on returning to the text, with an open mind this time, I found a couple of stories I had not previously used but that contained elements I could work into a landscape, including the golden head from 'The King of Colchester's Daughter' and the fiddle from 'The Far Travelled Fiddler'.

In the end I also decided to sneak in a reference to my favourite flying horse; you can spot him top left.

Painting and drawing musical instruments is always a challenge as I am edgy about accuracy with these items that are so precious to my friends in the folk music world, but I was quietly pleased with my fiddle in the end, and once again glad of the slow build of tones I can achieve with Inktense inks.

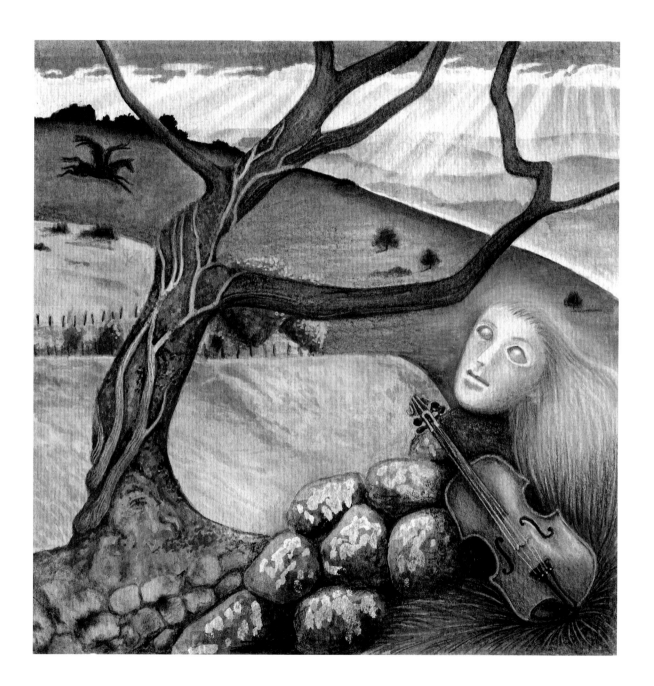

Dumfries & Galloway Folk Tales

BY TONY BONNING

This version of the Cinderella story appealed to me enormously because it has taken on so much that is characteristically Scottish to me and because Rashiecoat is not a passive figure, she is a determined young woman who wants to decide who and when she will marry and goes to great lengths to achieve this goal, setting her poor father a set of tasks and then leaving home rather than marry the man he has chosen for her.

'So be it!' her father said in resignation. He called a retainer and ordered him to collect a bag of grain and ask the birds of the air if they would give a feather in exchange for a beak-full of the cereal. Always glad of a free meal, birds came from far and wide, dropped a feather and made off with their fee. The Laird's tailor then zealously stitched every feather to a coat of the finest silk brocade. The Laird was highly impressed with the coat, as was his daughter, though her face looked glum. 'You don't like it?' asked her father in surprise.

I chose my niece Mary as the model for Rashiecoat, and also as the model for the fairy godmother, because there is an element here of making your own dreams come true rather than being reliant on others. Mary represents to me a generation of women who I hope will be able to take complete control of their own futures and make of them anything they wish.

Rashiecoats could not make out the face from the bright light that shone around it, but she noticed a circlet about the head decorated with leaves and flowers. 'Don't be afraid,' the phantom said kindly …

Early in the story her mother places this same circlet on the head of her daughter Rashiecoat when they are out walking together. It says to me, find that light inside you, be your own saviour.

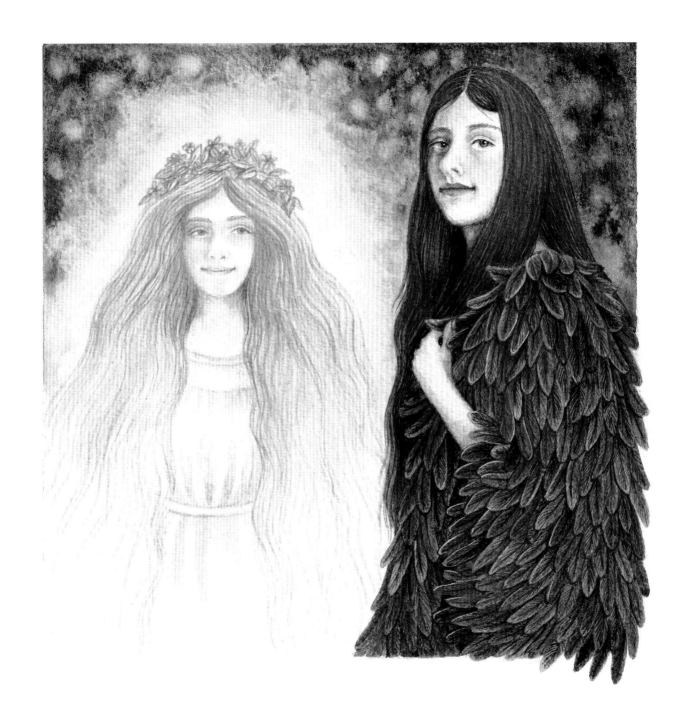

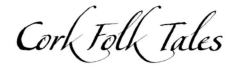

Cork Folk Tales

BY KATE CORKERY

This was the second time I depicted Manannán Mac Lir, so he is the only character who appears twice in the Folk Tales covers. But the image of Manannán holding the child of Cian in his cloak jumped out at me immediately and would not be denied:

'Do you remember our bargain?' said the old man
 'I do,' said Cian, 'to give you half of what I got on the island. But I only have the halter and the child.'
 'I had your word on it.'
 'I cannot give you the halter,' said Cian.
 'Therefore I will take the child,' said the old man, 'and I will have him fostered and brought up like my own son.'
 'Then take back your cloak, old man,' said Cian, 'and protect my child.'
 As the old man took the baby in his arms, Cian wrapped the cloak around them, and when he spread it out it had every colour of the sea in it and a sound like the waves when they break on the shore. The old man was beautiful and wonderful to look at. With beaming face and twinkling eyes, he lifted the little Sun God aloft and said, 'Cian, son of Dian Cécht, you will not regret this, for I am Manannán Mac Lir, God of the Sea. When you see your child, Lugh, again he will be riding on my own white horse, and no one will bar his way on land or sea. Now take farewell of him and may gladness and victory be with you.'

This beautiful passage was my inspiration for the cover of *Cork Folk Tales*; sometimes you read a few lines and everything is there in your head immediately. The challenge then is to try to transfer it to paper. The baby proved the most difficult aspect, as they can all too easily end up looking like tiny adults if you aren't careful with their proportions … I think the little Sun God worked out in the end, but he went through a number of alterations along the way. Manannán's cloak was a real labour of love though, I very much wanted to own it by the time it was finished, and often imagined wrapping its soft folds around me as I worked at my desk in the chill light of January.

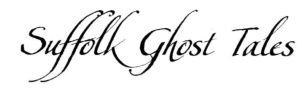

Suffolk Ghost Tales

BY KIRSTY HARTSIOTIS AND CHERRY WILKINSON

A dog-headed monk! How delicious, I thought. (There was also a corresponding monk-headed dog in the tale, I suppose the spares needed a home, but my favourite monk/dog combination was definitely the former.)

I immediately set about looking for an image of a dog that would be a good candidate for enrolment to the clergy. Nothing, not a single dog seemed to fit the bill – I just couldn't make any of the ones I found work and I needed a basis from which to start at least.

Then I found a picture of a rubber dog's head on a well-known shopping site, one where I have formerly purchased both a rubber donkey and a rubber rabbit head, but that is definitely another story.

It was perfect! Not quite dog, and not quite 'not' dog. I sketched it out as the basis for my piece, relishing its weirdness and looking forward to hours of layering Inktense to produce the right atmosphere of strange woodland around it.

As usual, I posted it to my Facebook page as a work in progress.

Meanwhile, in Stroud, author Kirsty Hartsiotis was following its progress:

I had an uncanny sense that Katherine might select this tale as the one she'd illustrate! I suspect her sense of whimsy might be a little similar to mine! This dog-headed monk was not as fierce as this in its original incarnation, and here Katherine's willingness to canvass opinion from not only the authors but also her friends and followers came into its own. There was a lively debate about whether he should be fiercer, Katherine listened and thought about it … and fierce he became! The *Ghost Tales* covers have quite a different vibe to the Folk Tales [series], Katherine truly captures the spookiness necessary in such an undertaking, making the two series properly distinct.

So the rather innocuous but suitably odd dog mask morphed into a darker being altogether, with fathomless eyes and a sneering sort of snarl, his semi-transparent head run through with veins of tree branches and tinged a sickly yellow. I loved painting him.

East Lothian Folk Tales

BY TIM PORTEUS

The story of the indestructible and determined Thenew, the 'holy princess', was not only a chance to portray another strong female character but also to paint a coracle, a style of simple boat that is also characteristic of the Ironbridge Gorge, where I live. I soon discovered that this basic approach to making something that floats is also common in many other countries and cultures and spent some fascinating time exploring images from North Africa and the Americas before finally pulling myself back to the task in hand.

With Thenew praying, the tiny vessel was cast into the Firth of Forth. She drifted on the tide out towards the sea, the water lapping at her feet as she desperately tried to avoid capsizing. She frantically scooped the water with her hands, but the land began to vanish and the water grew darker.

She approached the Isle of May, and here her spirits were lifted. The fish followed her, as did seals and the gulls above. She was no longer alone. Her small vessel began to move back into the Firth.

I loved the idea of the birds of the Isle of May coming to greet her and quickly discovered that the isle is home not only to gulls, but to many other seabirds as well, including puffins, one of my favourites. I had never painted a puffin before so looked for images that would inform me about their size when interacting with a human – I was amazed to discover how tiny they are! But that made it all the more perfect somehow. My friend and neighbour Holly posed on my living room floor as Thenew, as it was a piece where I definitely needed a real-life model and she was perfect for the role and even had a suitable dress.

Painting someone actually sitting in a coracle in a way that worked threw up a few problems. In my initial sketch I had Thenew sitting on the traditional plank seat most contain, but when I came to draw out the finished version the angle I had chosen so I could show the interior of the boat and have it angled towards the viewer looked rather odd and awkward. So I removed the seat and had her sit in the bottom of the boat as it rides the frothy waves of the Firth.

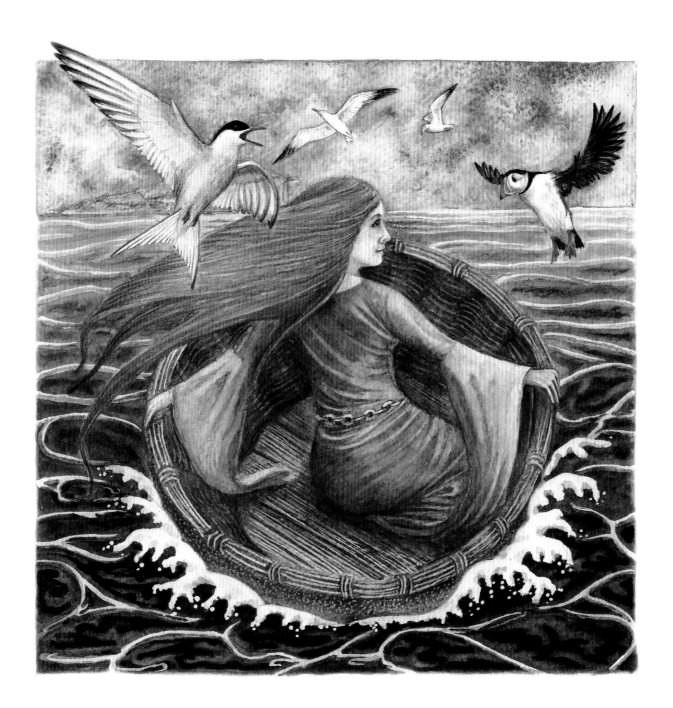

Limerick Folk Tales

BY RUTH MARSHALL

A great queen, at other times Áine seems to be a young girl or an old woman. She is a lover, a rape survivor, a mermaid, mother of a poet, the woman who knits, the Cailleach. She is a true goddess, and her presence can still be felt in the landscape, in the air, in the names given to landscape features.

When I came across this passage in *Limerick Folk Tales* I knew she had to be the subject of my cover illustration. She is every woman. She is also for me an image of my mother, who I remember knitting in the evenings when I was small, her long dark hair in bunches and her feet folded neatly underneath her in an armchair. That subtle but continuous clicking of the needles as she knitted for my younger sisters. I never became a knitter; my skills lie in weaving my dreams in pencils and paint, but I still find the image of a woman knitting an evocative one and the idea of there being so much power in such a gentle process is one I am incredibly drawn to. As I dreamed and doodled, wondering how my knitting goddess should look, I received a message from the author, Ruth Marshall, expressing the hope that I would choose this story for the cover image …

For me, words conjure images which in turn conjure words, and so I was also reminded of this beautiful poem, 'In Hospital', by Tom Leonard:

I like seeing nurse frieda knitting
as I like watching my wife knitting
as I like watching my mother knitting
though she was more of a dabber
(plain and purl, plain and purl)

it's not
"women being in their place"

just
the future, knitting the future
the present peaceful, quiet
as if

the same woman knitting
for a thousand years

As soon as I mentioned on social media that I was interested in photos of people knitting to use as resource material, the response was amazing. I received dozens of pictures of exquisitely busy hands and although none were quite what I was after, I suddenly became aware of the love and enthusiasm so many felt for this gentle art. Ruth loves this image, and that also makes me happy.

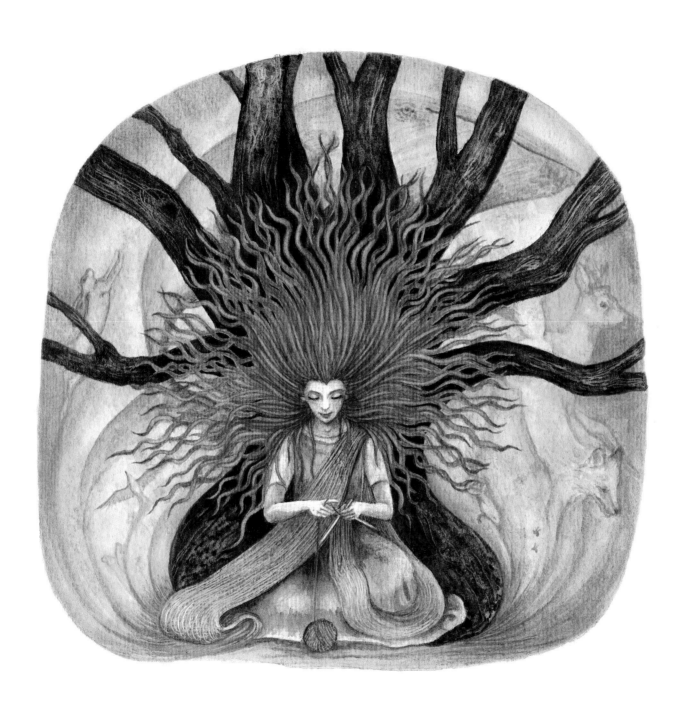

The History Press

The destination for history
www.thehistorypress.co.uk